On Common Ground

On Common Ground

The Vanishing Farms and Small Towns
of the Ohio Valley

JAMES JEFFREY HIGGINS

The Kent State University Press KENT, OHIO, & LONDON

© 2001 by The Kent State University Press, Kent, Ohio 44242

All rights reserved

Library of Congress Catalog Card Number 2001029687

ISBN 0-87338-714-7

Manufactured in China.

06 05 04 03 02 01 5 4 3 2 1

Library of Congress Cataloging-in-Publication Data

Higgins, James Jeffrey, 1958–

On common ground : the vanishing farms and small towns

of the Ohio valley / James Jeffrey Higgins.

p. cm.

ISBN 0-87338-714-7 (cloth : alk. paper) ∞

1. Country life—Ohio—Pictorial works. 2. City and town life—Ohio—Pictorial works.

3. Farms—Ohio—Pictorial works. 4. Cities and towns—Ohio—Pictorial works.

5. Ohio—Social life and customs—Pictorial works. 6. Ohio—Rural conditions—Pictorial works.

7. Ohio River Valley—Social life and customs—Pictorial works.

8. Ohio River Valley—Rural conditions—Pictorial works. I. Title.

F492.H46 2001

977'.009734—DC21 2001029687

British Library Cataloging-in-Publication data are available.

I dedicate this book to my mother,

Barbara Toth Higgins,

who passed away on January 19, 2001.

Words will never adequately express how much I miss her.

Contents

Preface

In the spring of 1987, a friend of mine suggested we take a day trip from Youngstown south to East Liverpool, Ohio. Until then, I had never taken the time to see the Ohio Valley, so this was my first exposure to the soft rolling hills, lush woods, and serene valleys of southern Ohio. The landscape, which reminded me of a Thomas Cole painting, etched itself on my memory. Drawn to the quiet beauty of the region, I found myself making the same trip the very next week. I never dreamed that something so breathtaking could be just a forty-minute drive from my home.

Later, while I was working on compiling the photographs for my first book, *Images of the Rust Belt,* I spent hours in the Ohio Valley taking pictures of our industrial Midwest. Though my camera was focused on rusted-out steel mills, abandoned rail yards, and collapsed smokestacks —forlorn remnants of our industrial past—I couldn't help but look beyond the viewfinder and see the struggle going on within the Valley's rural towns and on its small family farms. Like my own northeastern Ohio home, this region had been ravaged by the collapse of the local economy. Steel mills and foundries had closed, leaving these communities without any source of employment. Folks left the area to live and work elsewhere, leaving the beauty shops, diners, and hardware stores to falter, and sometimes fail.

The small farmer was losing ground as well, at an alarming rate of about sixteen farms a month. This was a national—not just statewide—trend, but this part of Ohio, with its tradition of dairy and wheat farming, was hit especially hard. Large-scale corporate farming pressured smaller farms to use their property as collateral in order to expand production and compete in the market. But with the vagaries of weather (harsh winters, flooding, tornadoes, drought), crop failure, and unexpected shifts and turns in the market, many farmers lost this gamble . . . and their land and homes. Urban sprawl contributed to the disappearance of the area's rich farmland. Desperate farmers were selling their land for a quick (but not great) profit to bargain-hunting developers with sights set on building lucrative housing subdivisions and impersonal superstores and yet another mini-mall.

But while the signs of hard times are evident throughout the Ohio Valley's towns and along its back roads, equally apparent among these very rooted people is the strong sense of place, of identity. I can't help

but think that their ties to the land, to the beautiful hills and glens and meadows, is what sustains them despite the economic pressures and hardships. These towns are still communities—a notion lost in the suburban sprawl plaguing the rest of the state. Though not grand or affluent, homes and businesses are neat and well tended; the quiet streets are tree lined and inviting. Here children still walk to school and play outside, not worried about traffic or crime. Here people sit on front porches and greet their neighbors. Here life is slower, more measured.

When I discovered photography in my early teens, I had no idea how my life would be affected by it, both personally and professionally, how it would forever change my understanding of the world, my perspective on all things. Nor did I ever think that my wandering, daydreaming disposition—an escape, perhaps, from my turbulent, chaotic childhood —would prove so fruitful. I didn't imagine that those long after-school meanders home would become purposeful someday, evolving into a passion for exploring landscapes familiar and foreign and capturing them with my camera.

But through my photographic explorations and adventures, I've come to understand that our lives are shaped by the circumstances we survive . . . and celebrate. I feel this keenly when I visit the towns and farms in the Ohio Valley. Here I am struck by the not-so-fragile relationship between man and nature. I'm struck by how resilient both are. And I'm reminded that while we never really own the land, together we are stewards of this common ground.

Acknowledgments

There are a number of friends and colleagues who have contributed immeasurably to this book, and I would like to thank a few of them by name.

First and foremost I acknowledge Divine inspiration.

Also, many thanks to my mentor, Robert Glenn Ketchum, for his continued support and belief in me as a photographer. As well, I extend my appreciation to David Cooper and Dr. Michael Schwartz for their generosity.

Many thanks to Joel and Nancy Sabella for their belief in me and for allowing me to work in their place of business, where I mounted and framed my photographs. Also, thanks to Tom Cornelius for his patience with and understanding of my career.

I thank Eileen Kolat for her assistance in proofreading my text. I would also like to thank everyone at The Kent State University Press for their belief in my work. I would never have been able to publish such wonderful books if they had not given me the opportunity.

As my career continues to progress, I thank the many people who have helped me along my chosen path.

All of the photographs were made with a Pentax 6 x 7 camera and with 75 mm, 105 mm, and 200 mm lenses, using Fujichrome Velvia film. The Pentax camera has been a faithful companion during these many years, and I want to thank everyone at Pentax Corporation for their assistance.

All things belonging to the earth will never change—the leaf, the blade, the flower, the wind that cries and sleeps and wakes again, the trees whose still arms clash and tremble in the dark, and the dust of lovers long since buried in the earth—all things proceeding from the earth to seasons, all things that lapse and change and come again upon the earth —these things will always be the same, for they come up from the earth that never changes, they go back into the earth that lasts forever. Only the earth endures, but it endures forever.

—Thomas Wolfe, *You Can't Go Home Again*

On Common Ground

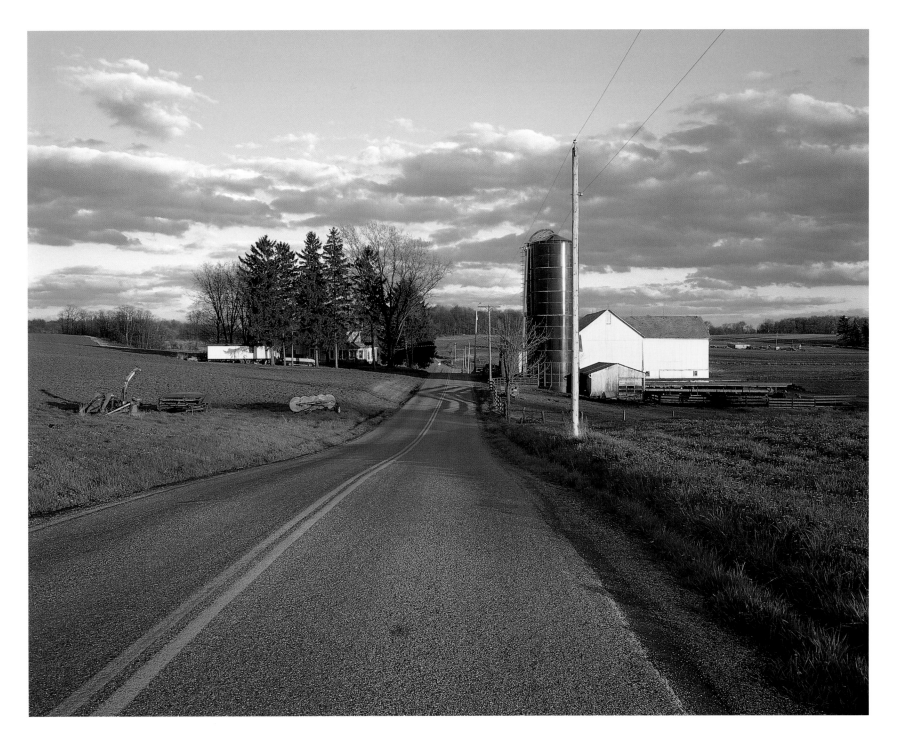

Late-afternoon sun

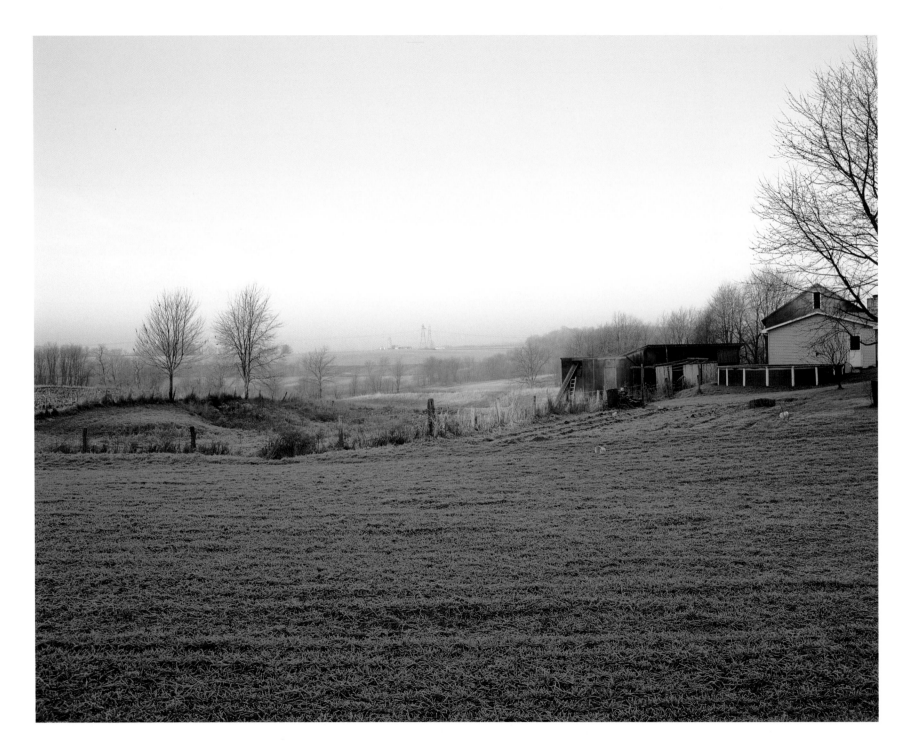

An early spring morning

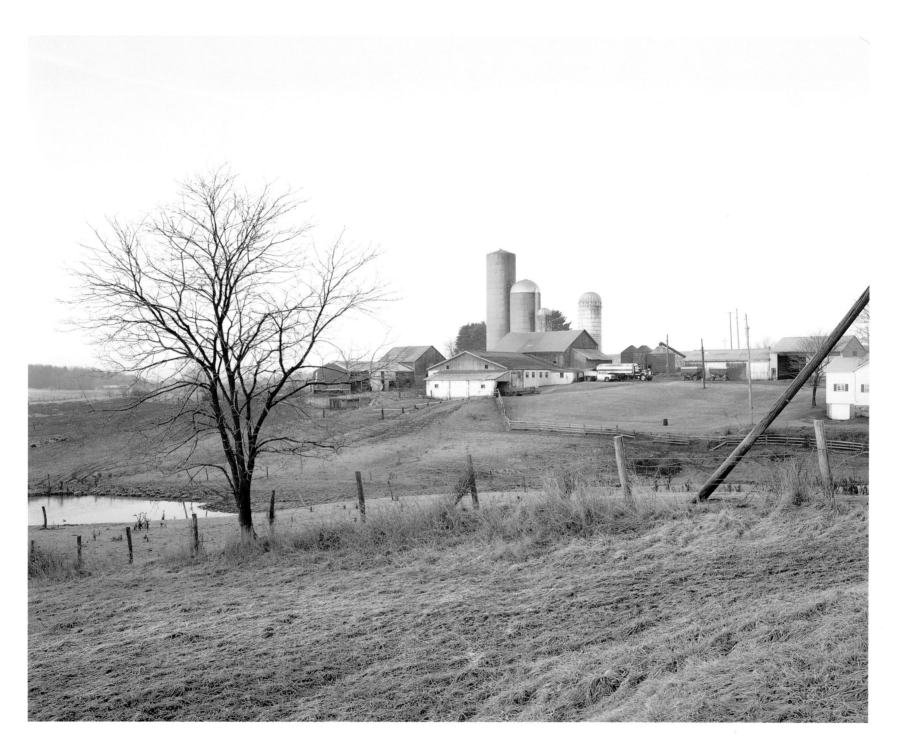

A farm at sunrise

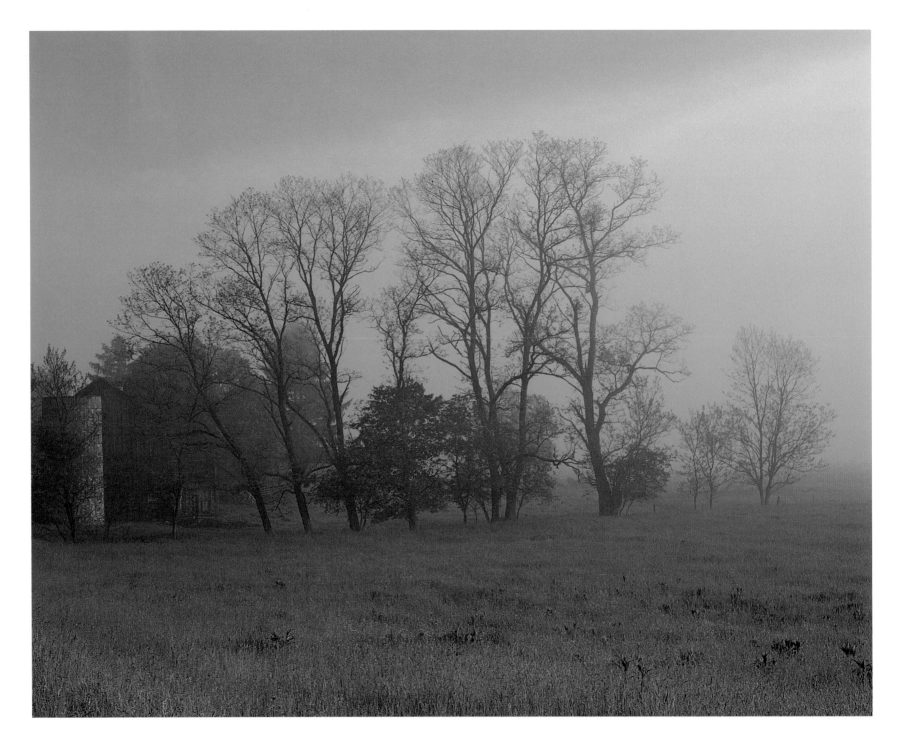

Trees in the fog

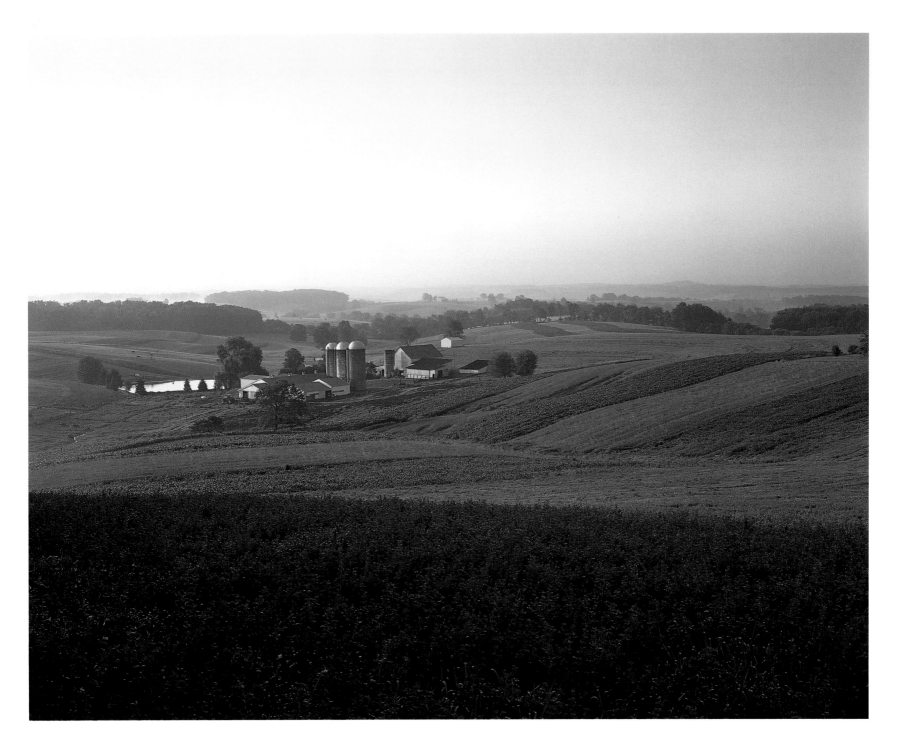

A farm from the hilltop

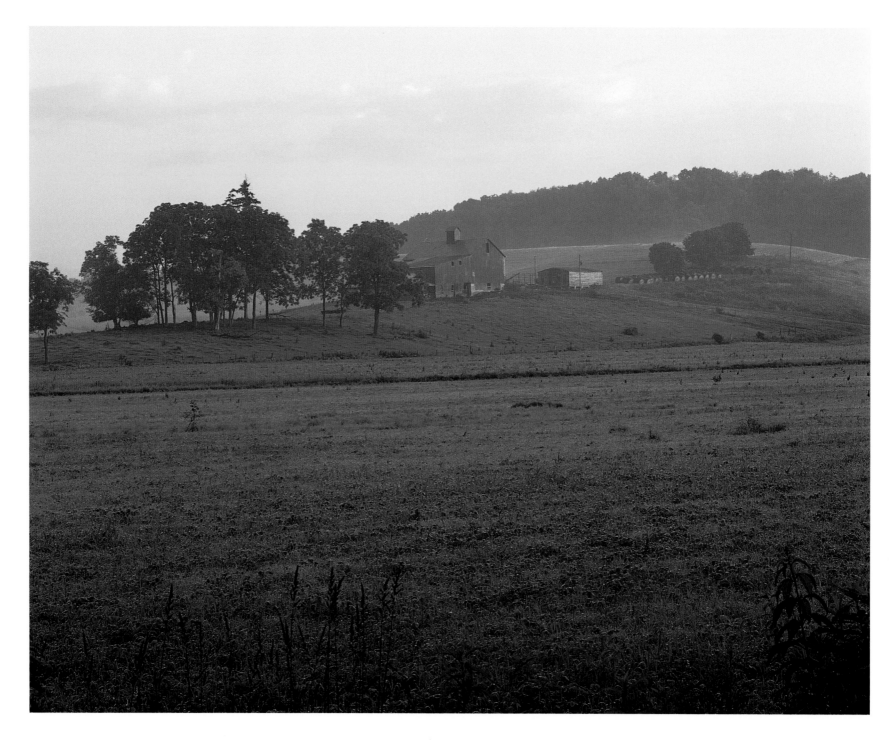

Sunrise in the valley

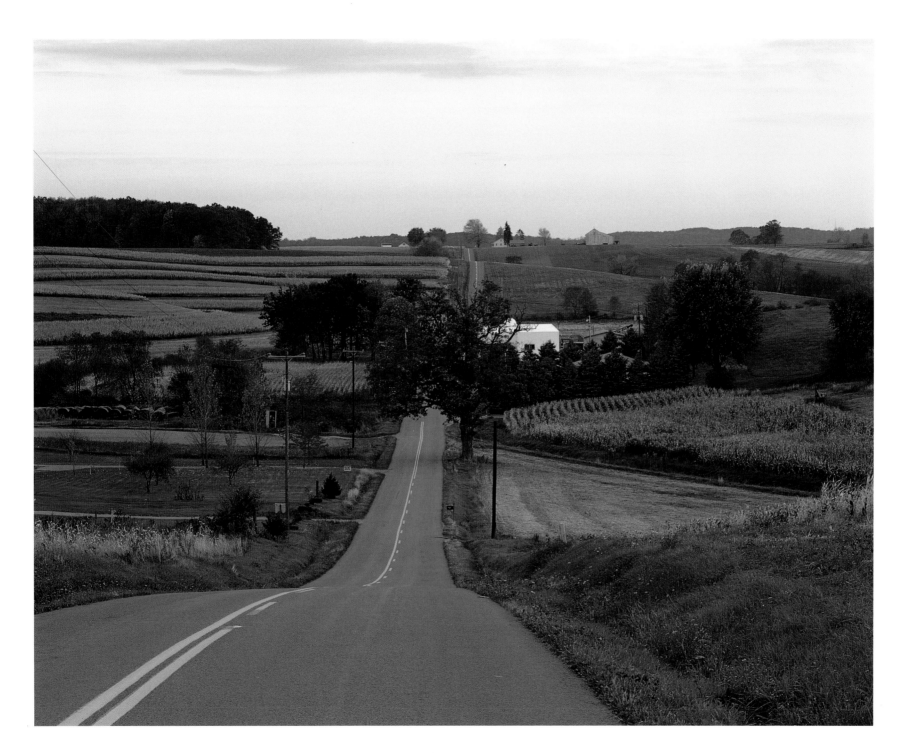

The long yellow line

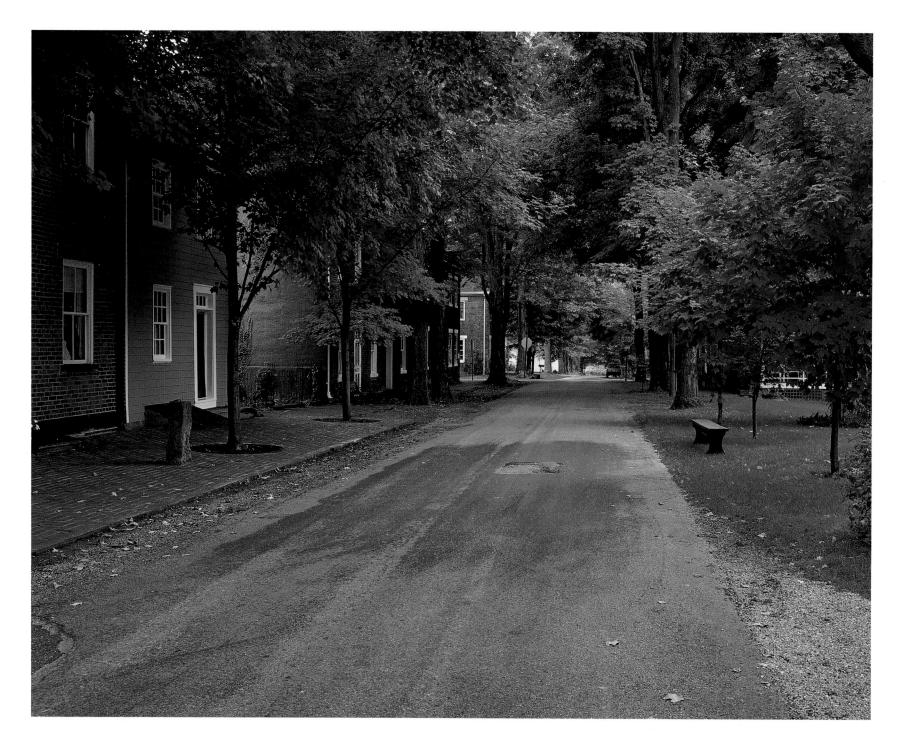

Hanoverton, Ohio

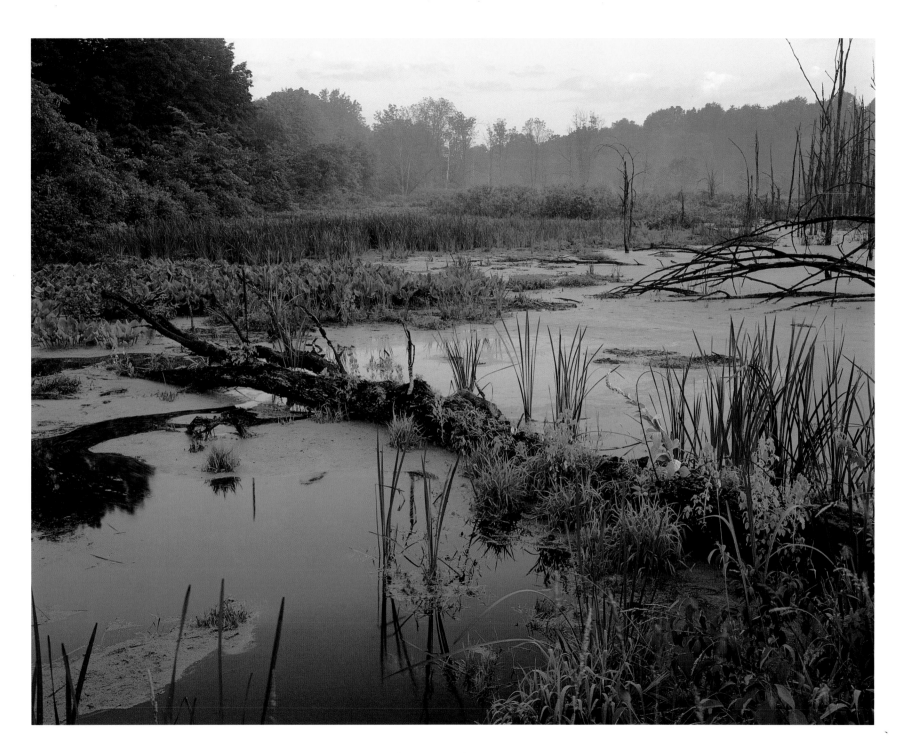

A swamp in the summer

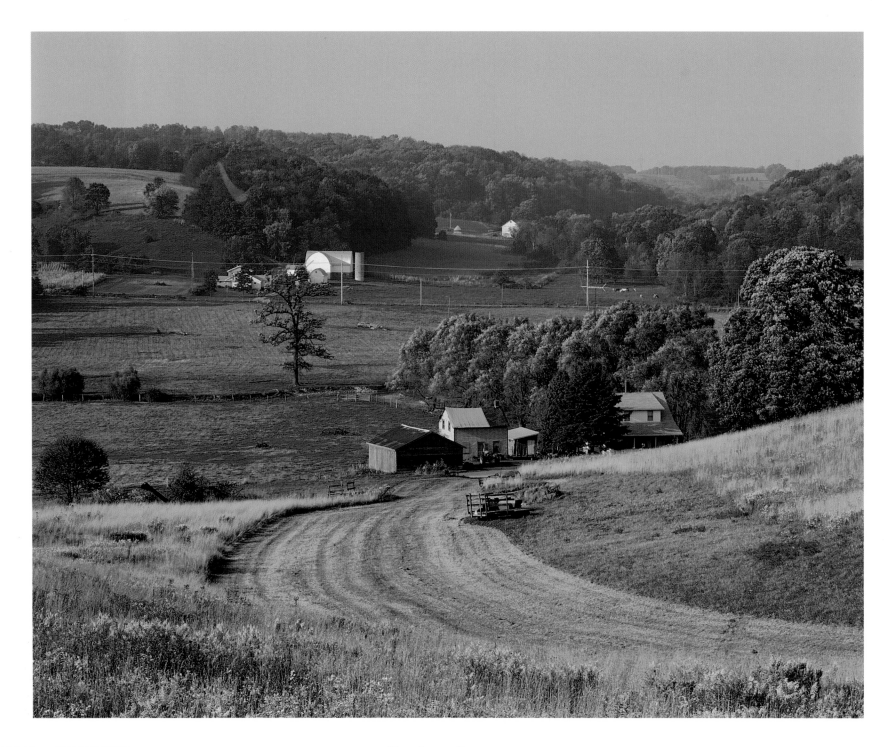

View from a distance

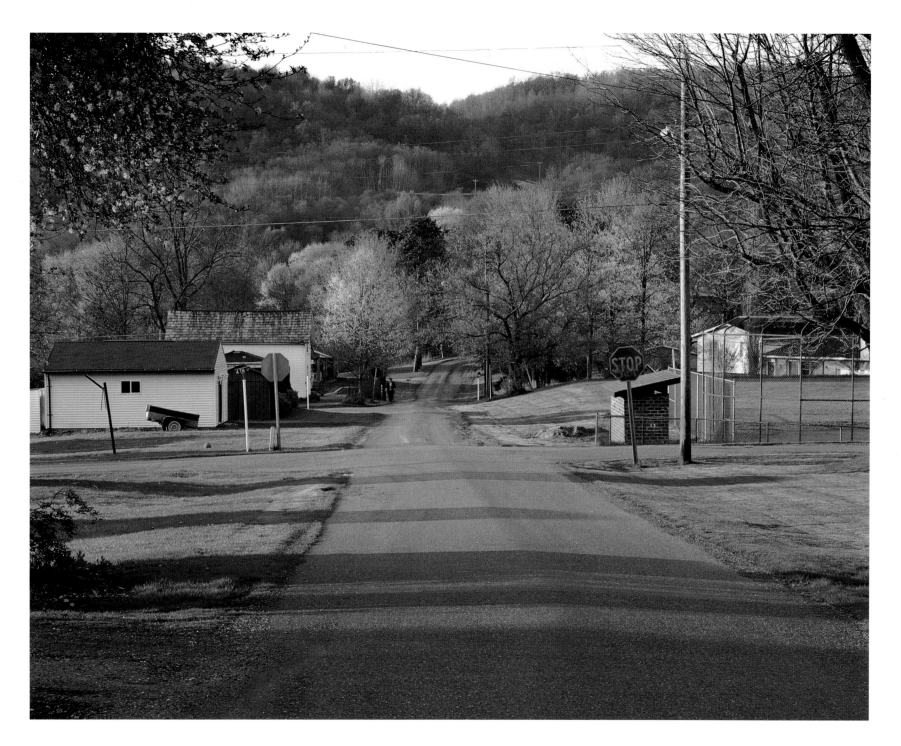

Streets in Bergholtz, Ohio

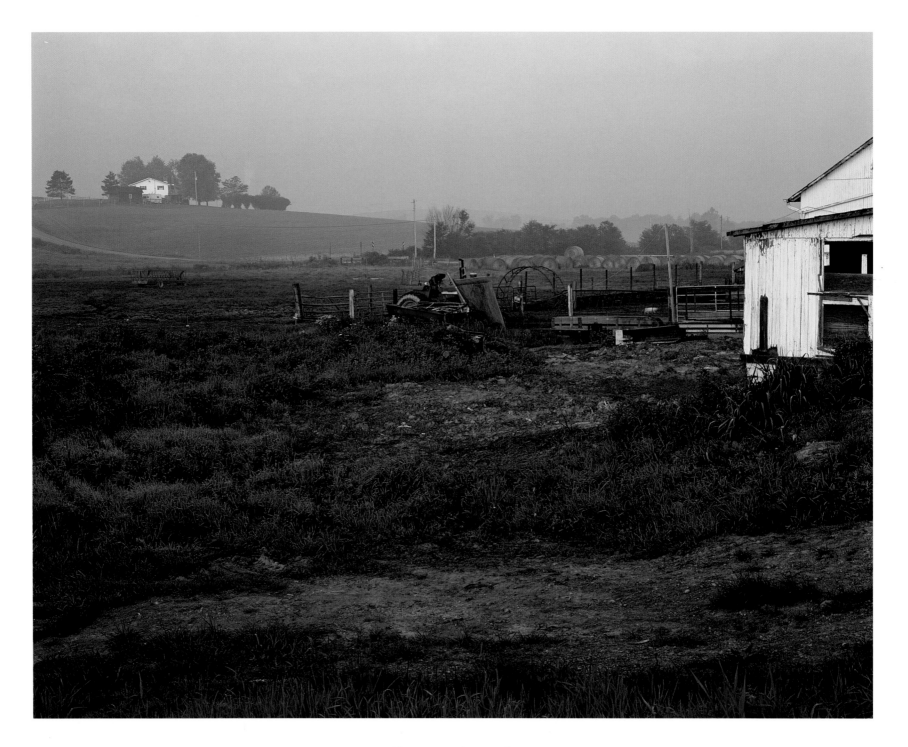

Tractors in a barnyard

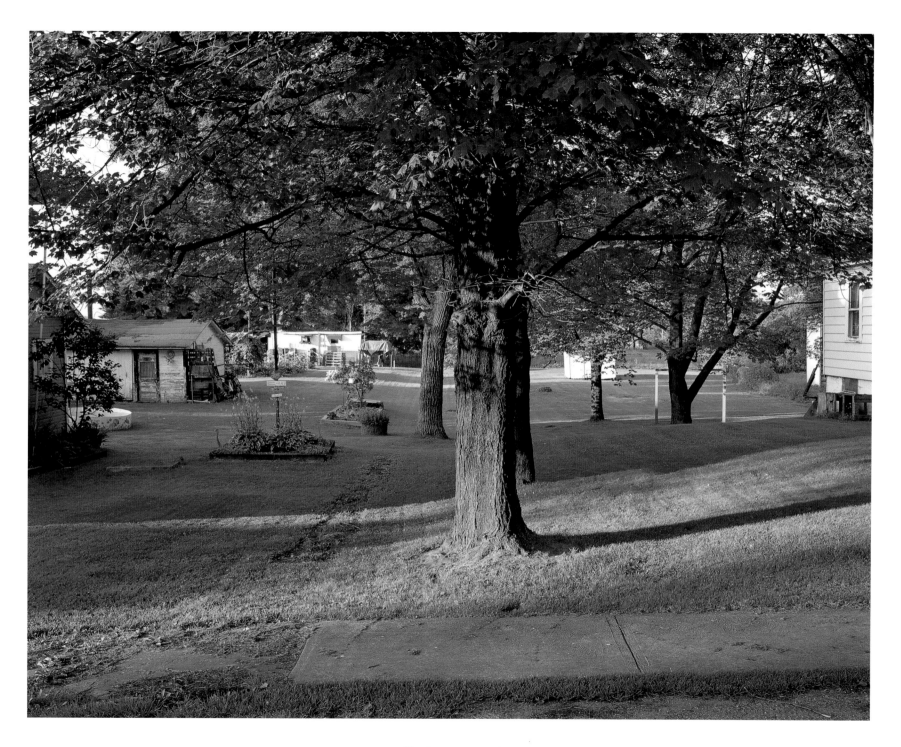

Shadows in a yard

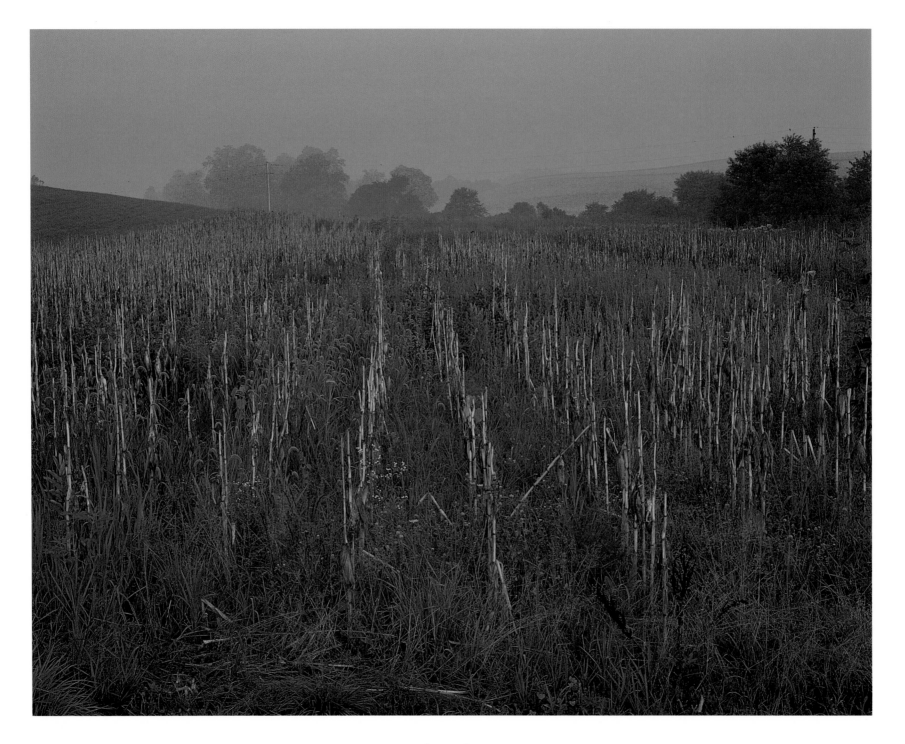

Cornstalks

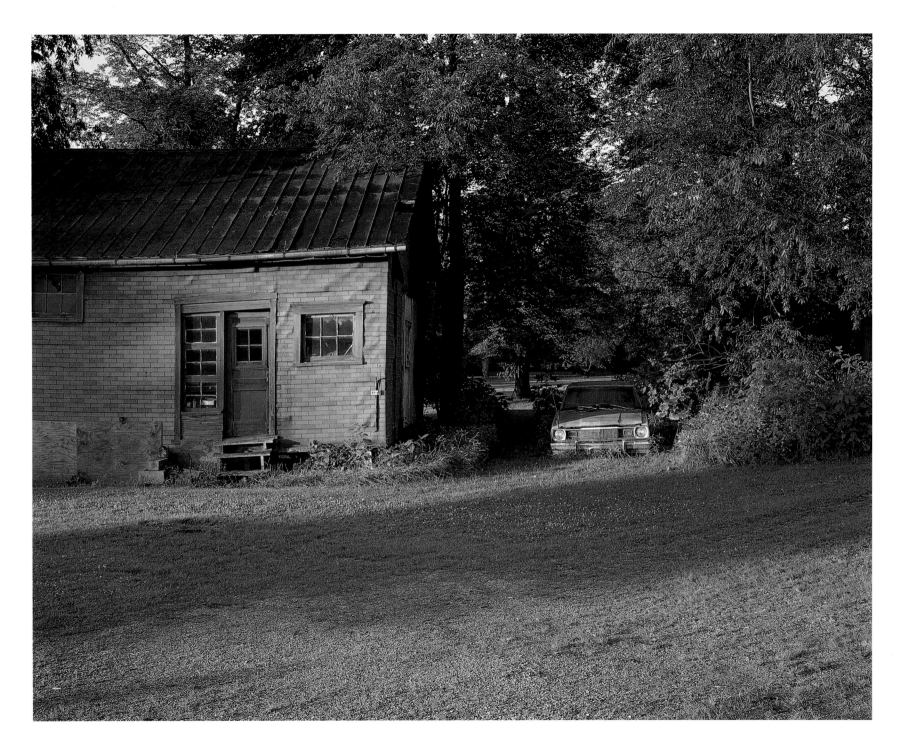

The old car

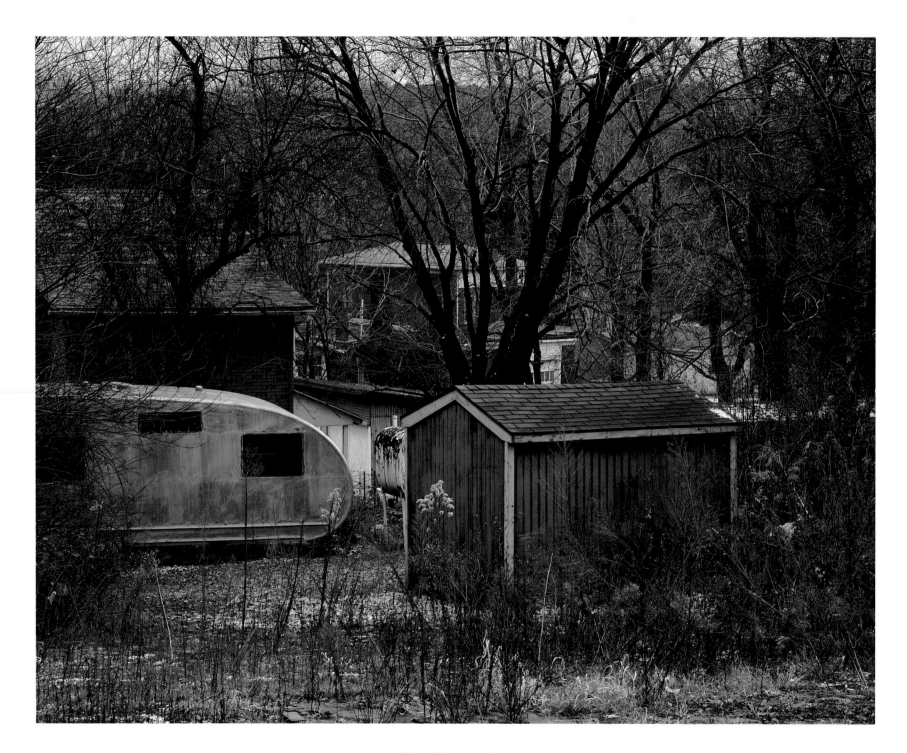

The old gray trailer

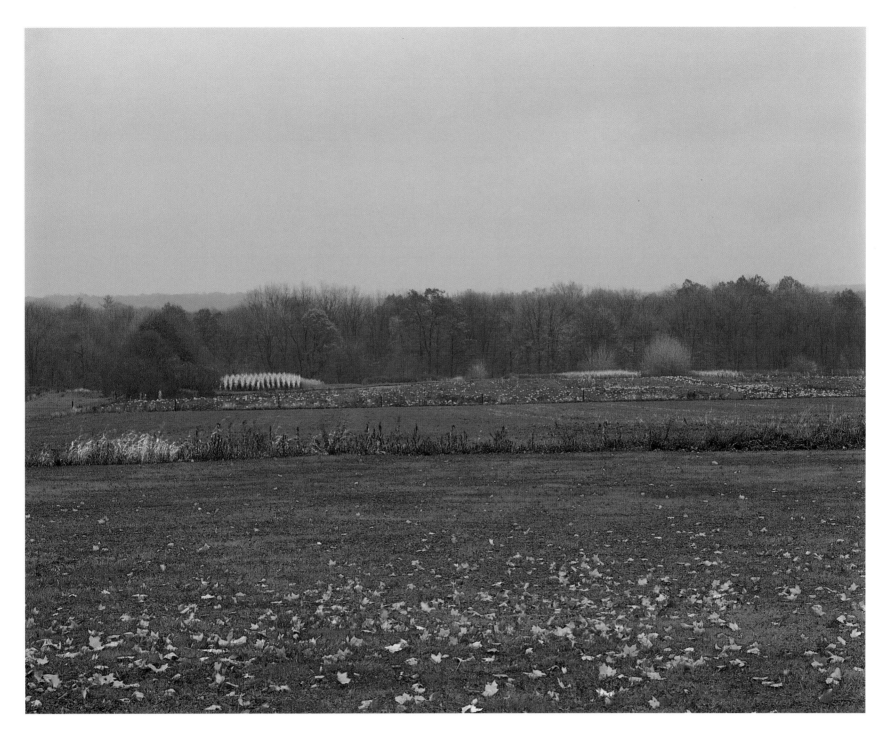

A pumpkin patch

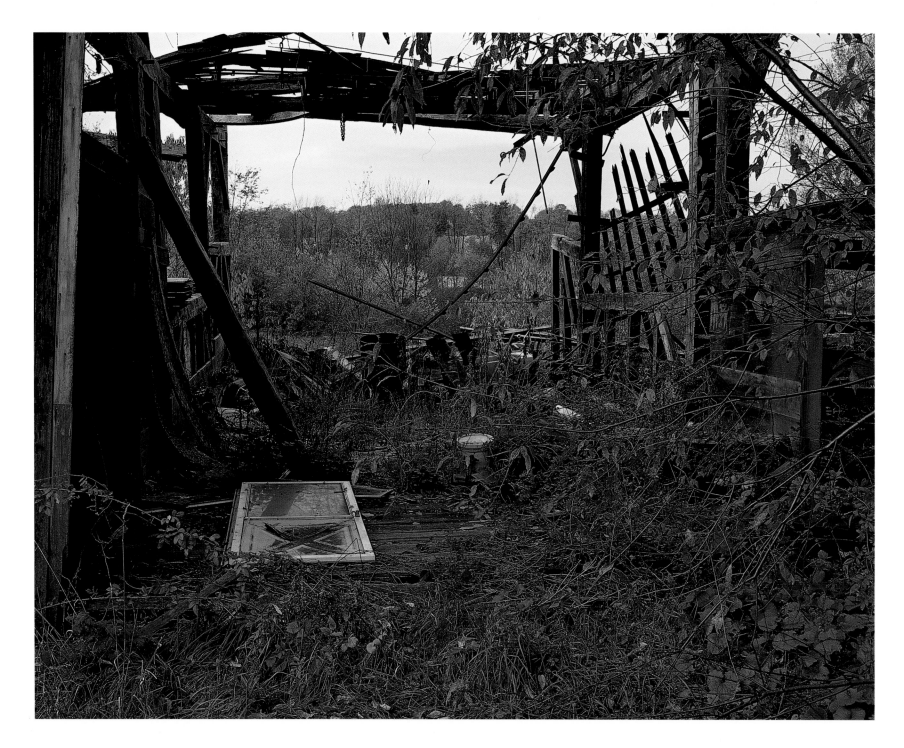

Bits of the past

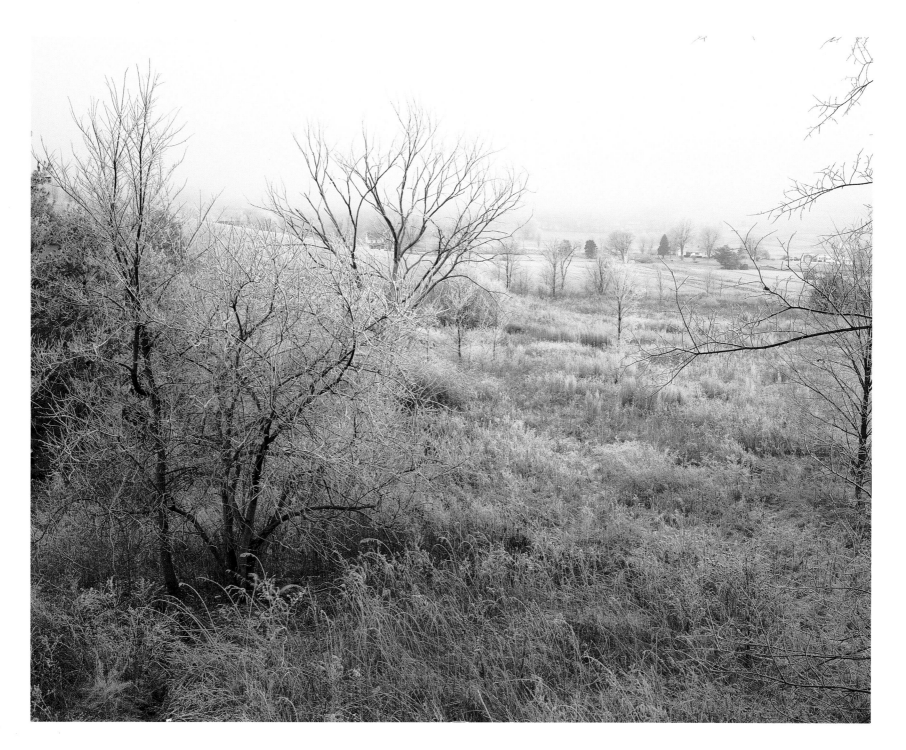

A frosty morning

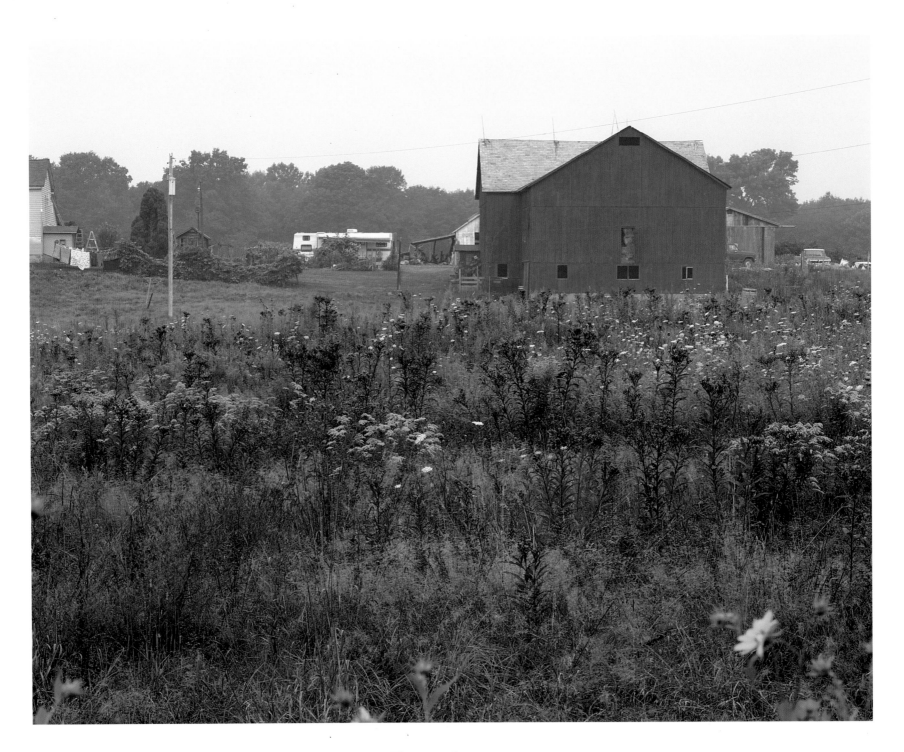

Flowers in the summer

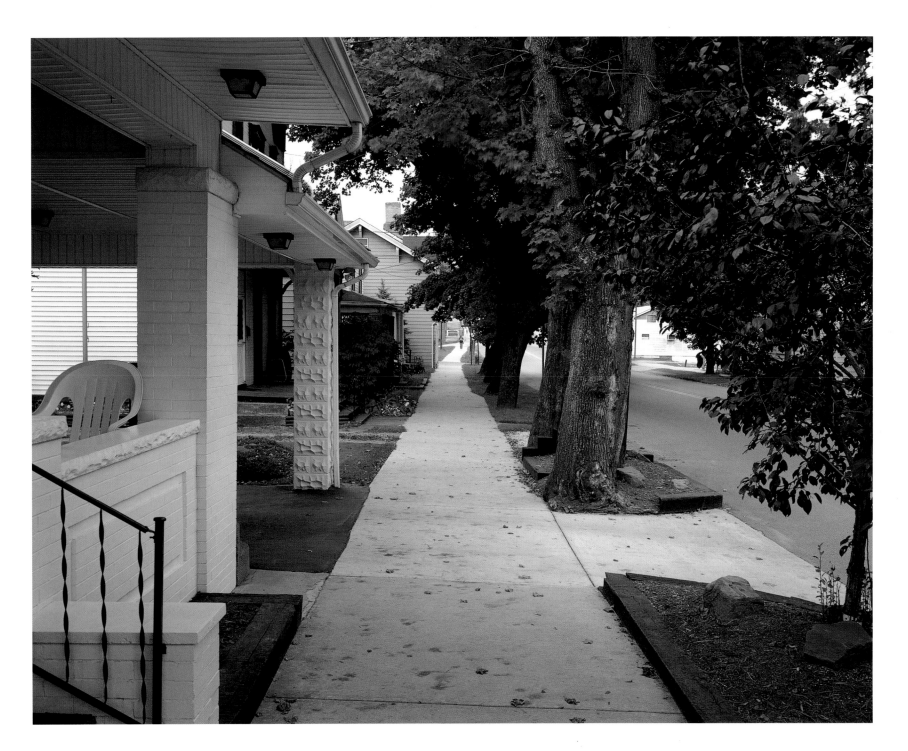

A sidewalk in Salineville, Ohio

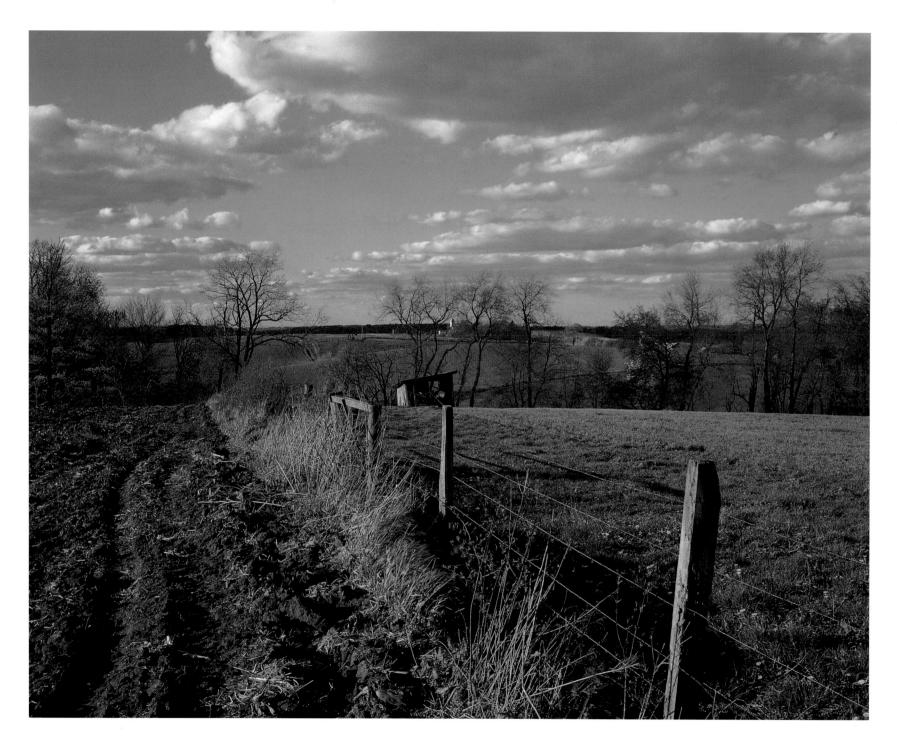

Fence posts

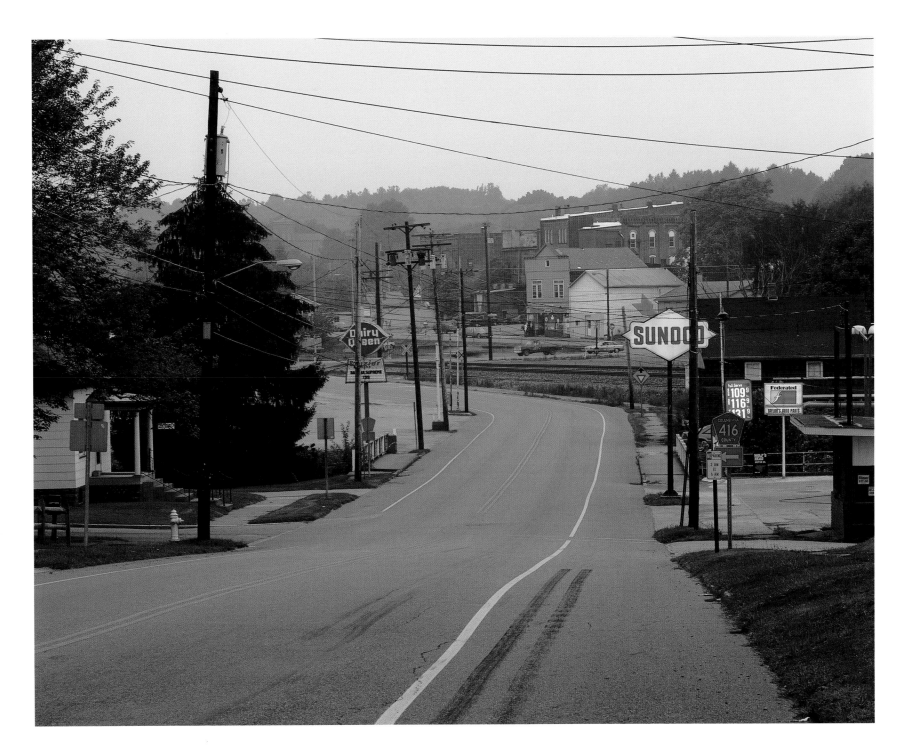

Downtown Leetonia, Ohio

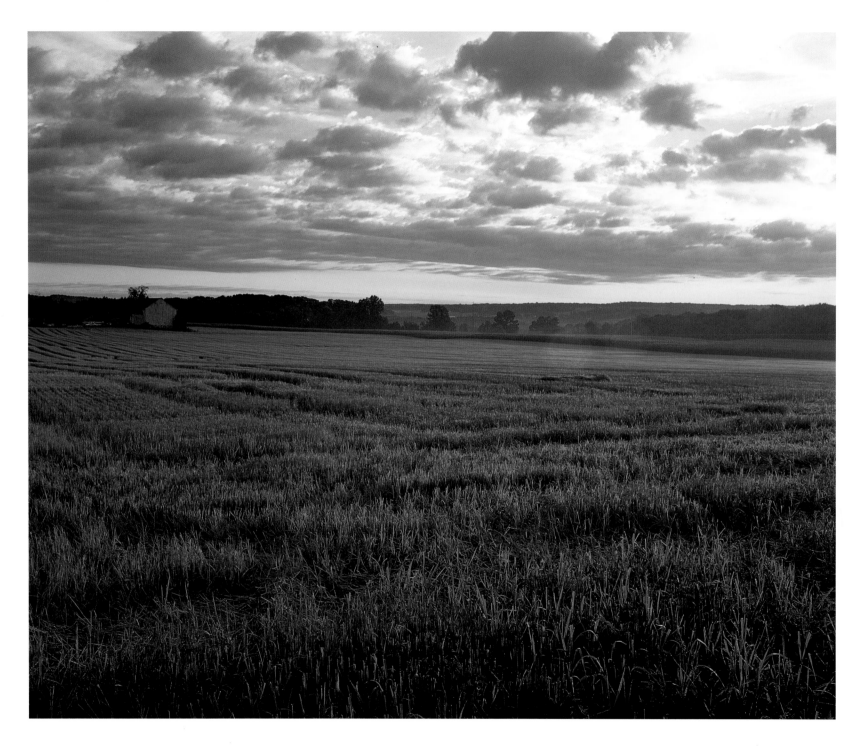

Amber waves of grain

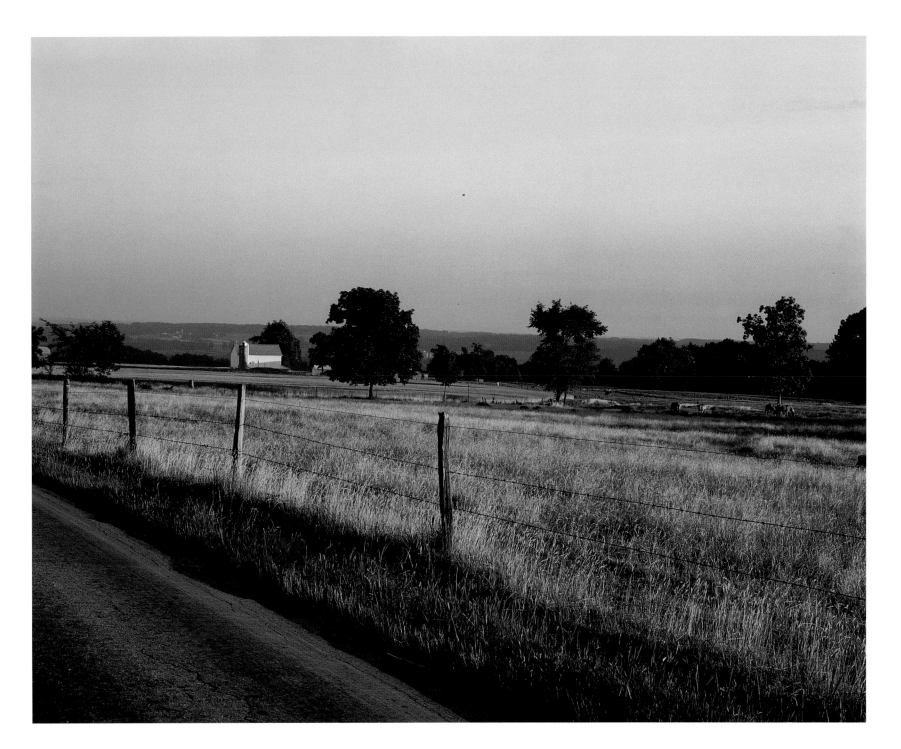

A field in Mercer County

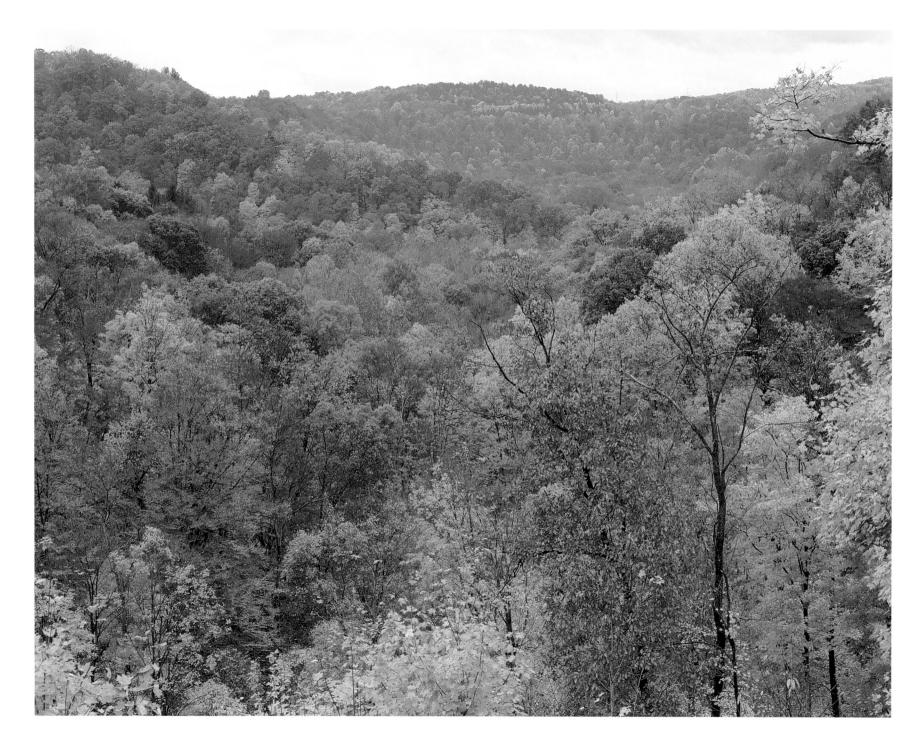

Fall colors in the Ohio Valley

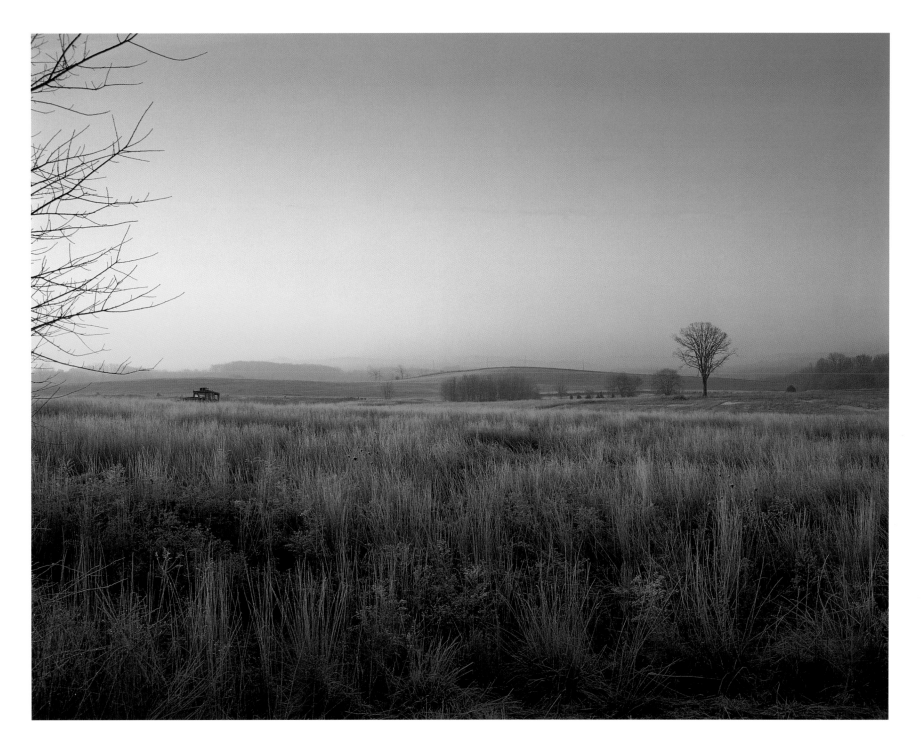

A frosty field

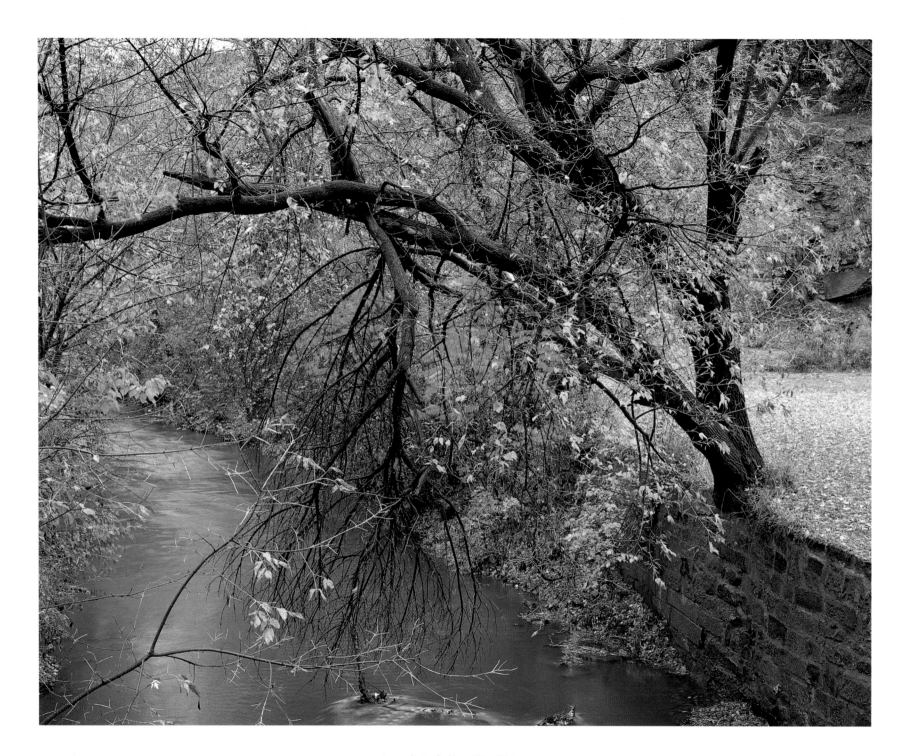

A creek in Salineville, Ohio

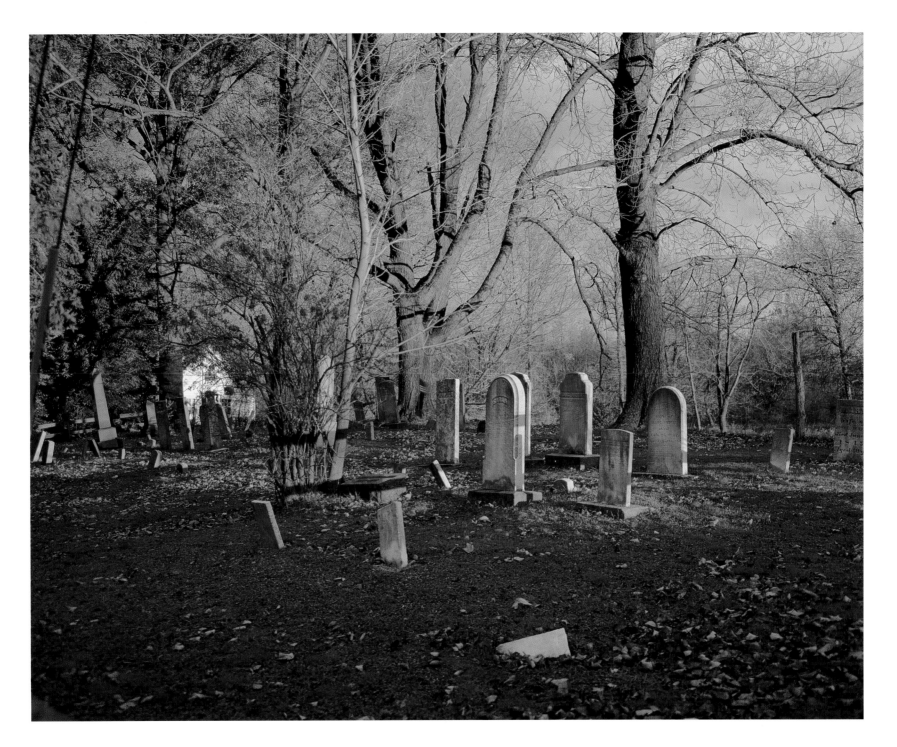

An old cemetery

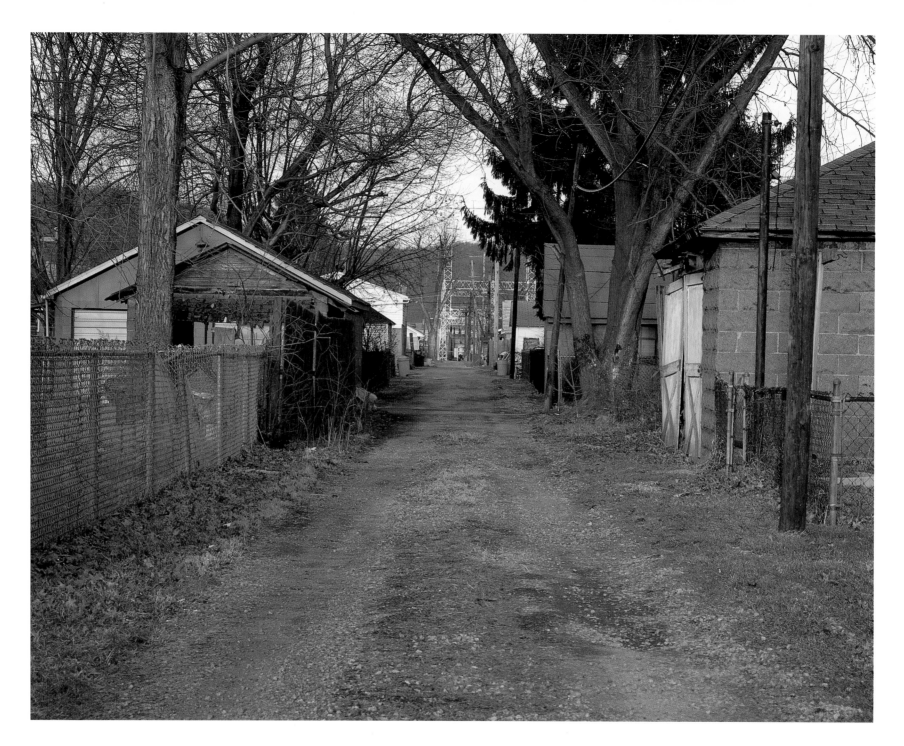

An alleyway in Wellsville, Ohio

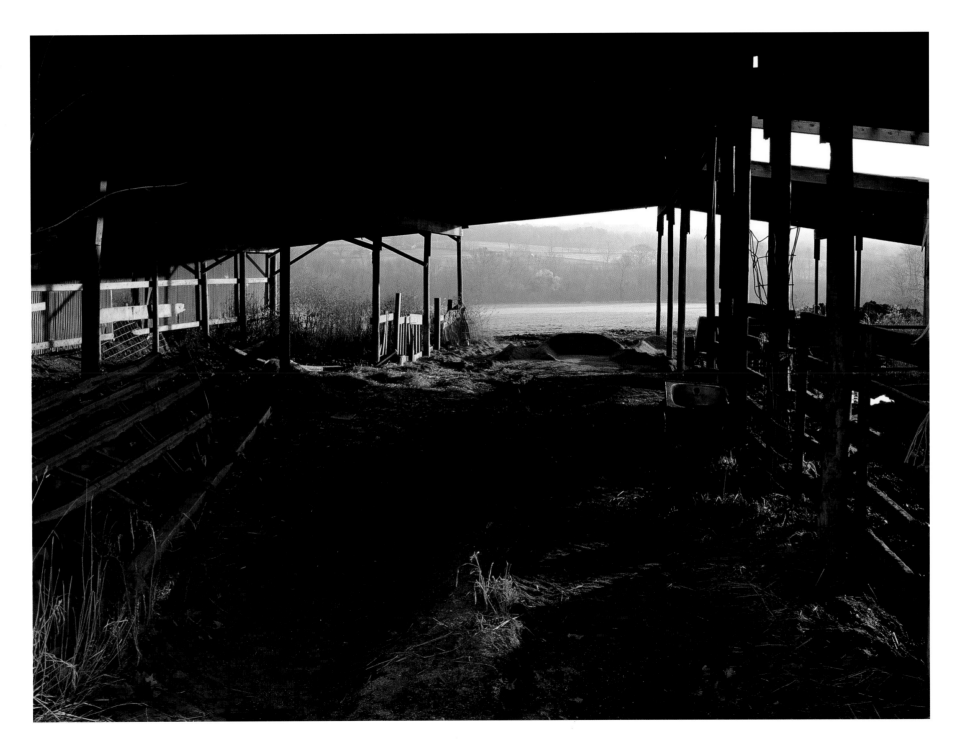

From the inside of a barn

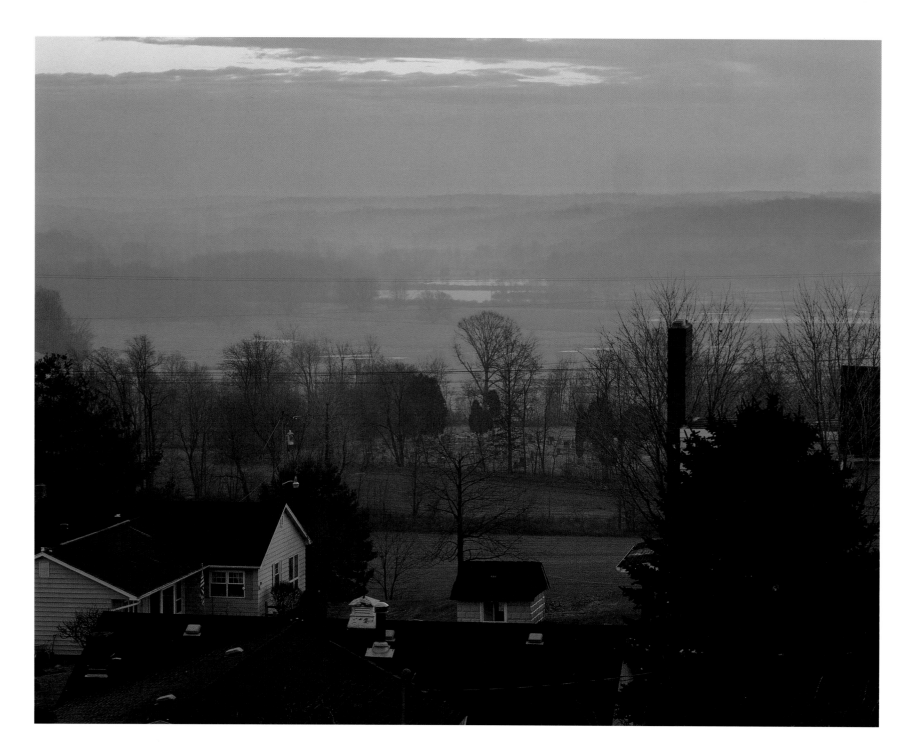

Sunrise in the Beaver Valley

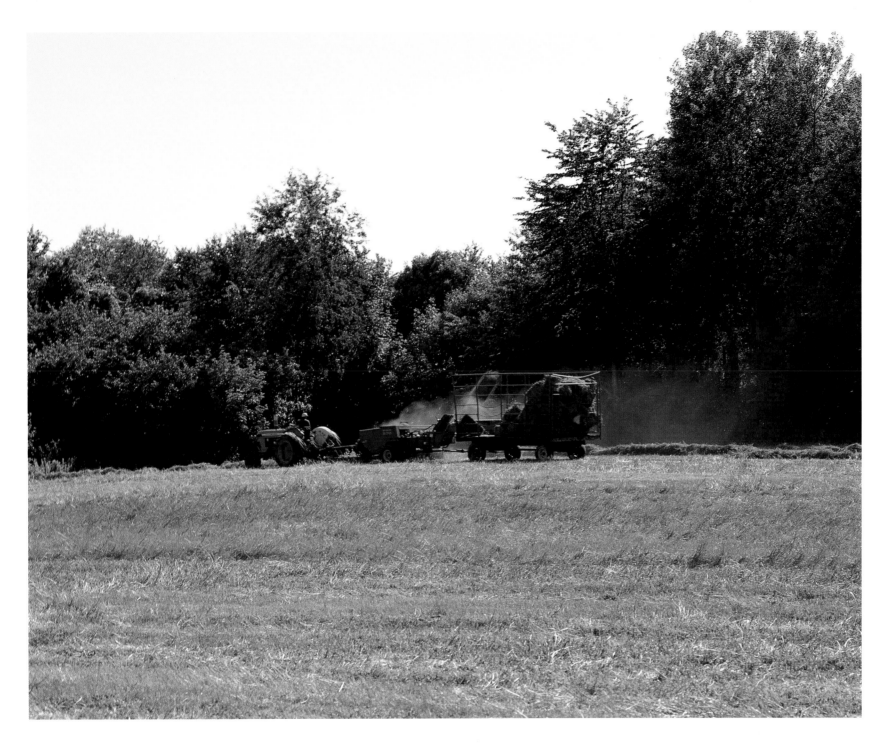

Loading bales of hay

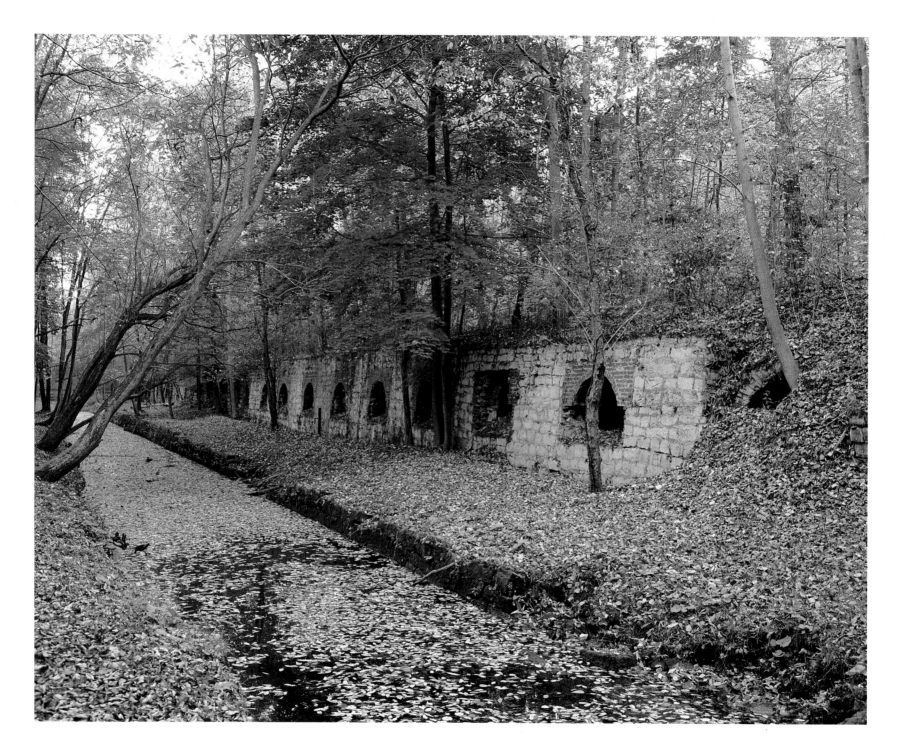

Coke ovens in Leetonia, Ohio

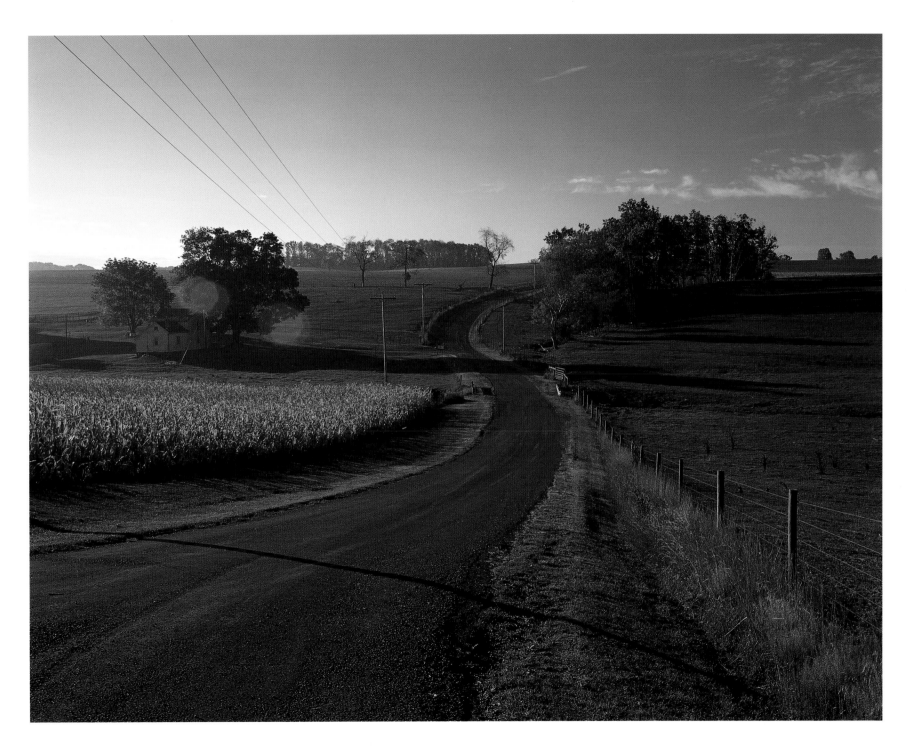

A stretch of road

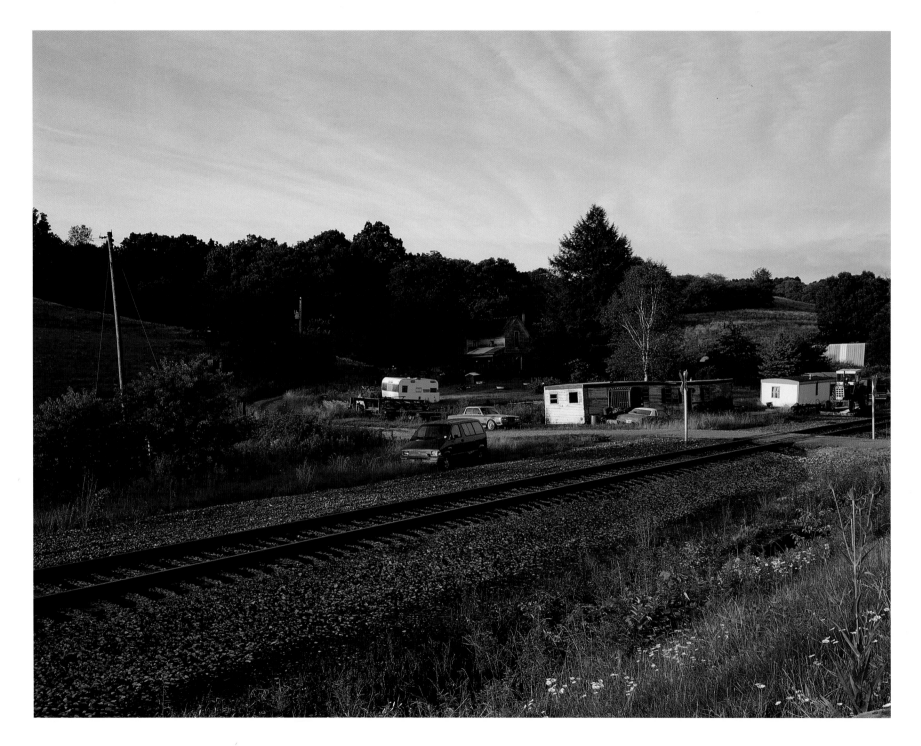

An old trailer along railroad tracks

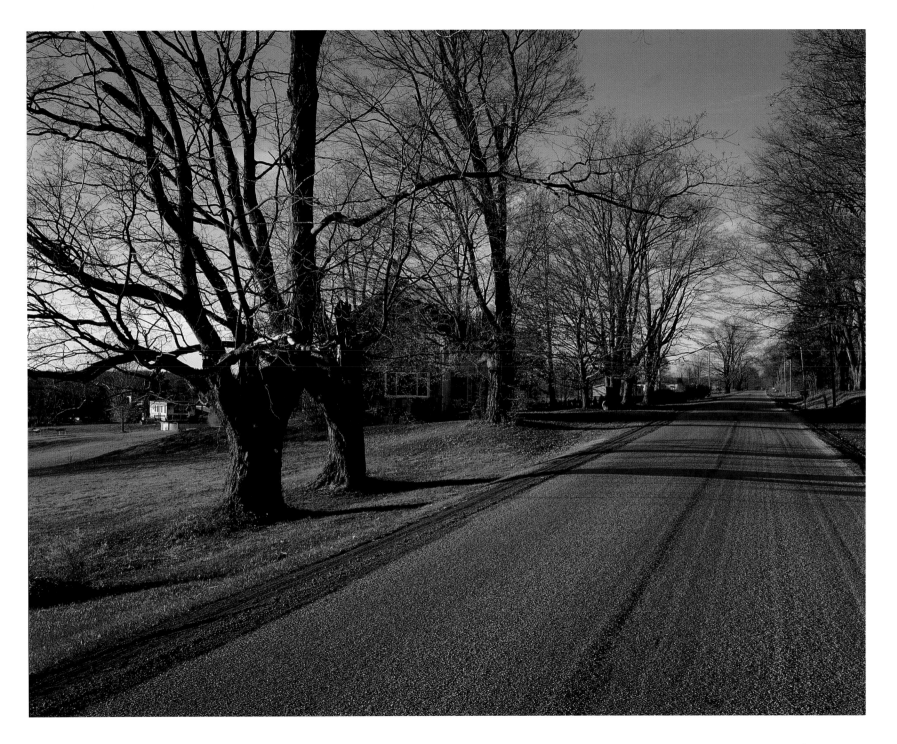

Along the road

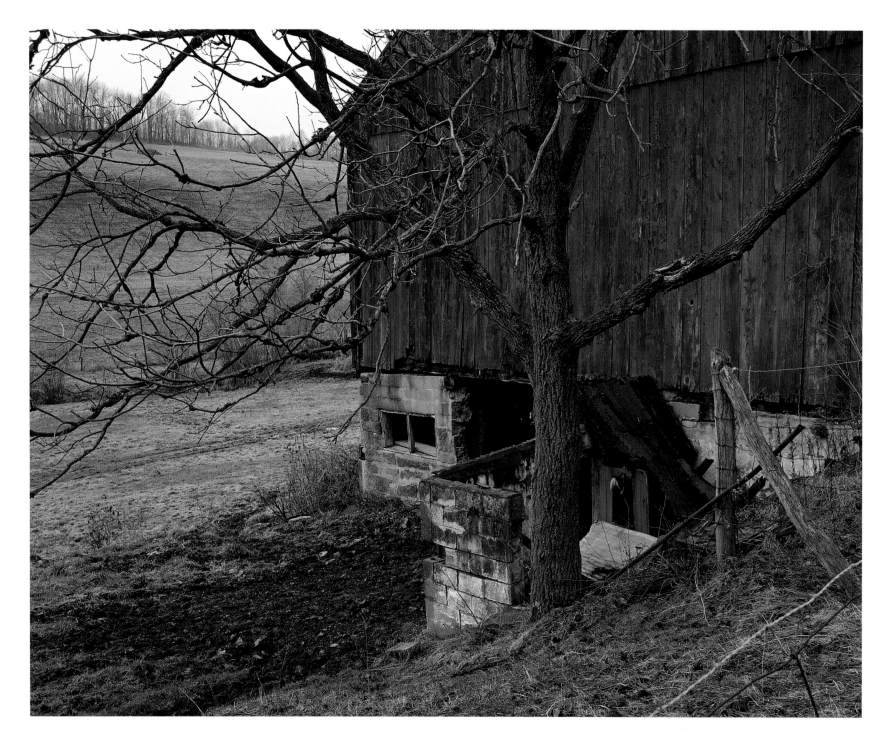

A barnyard scene

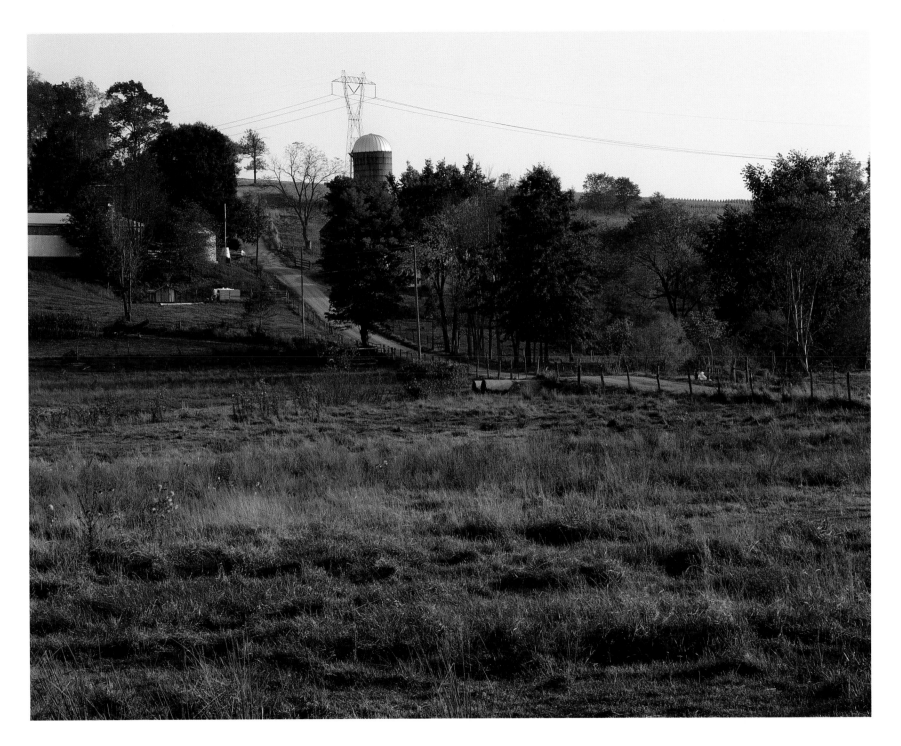

A view from the road

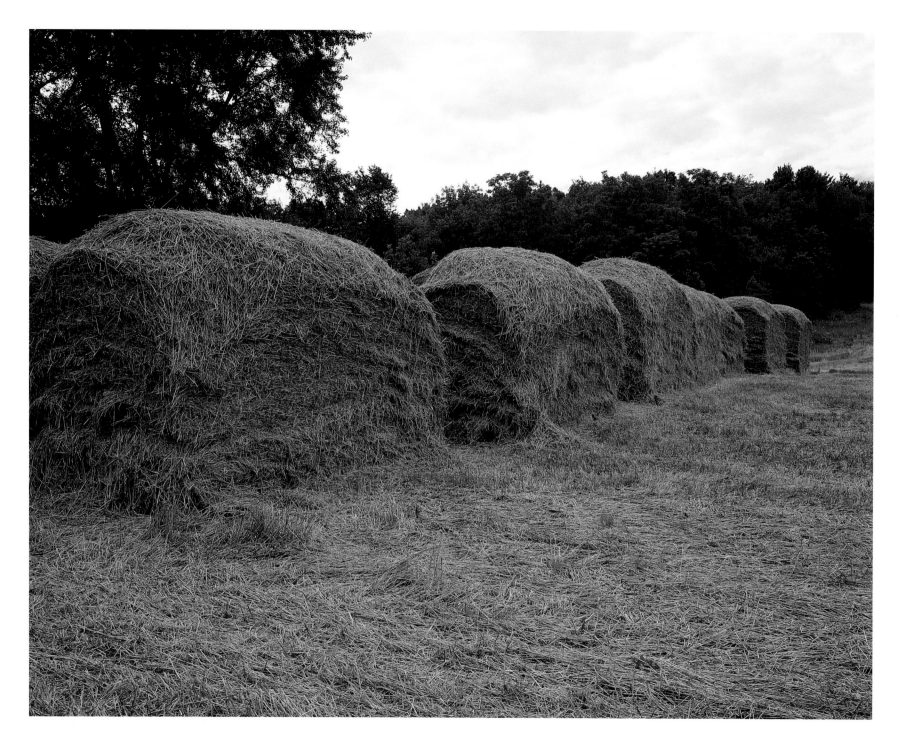

Hay bales

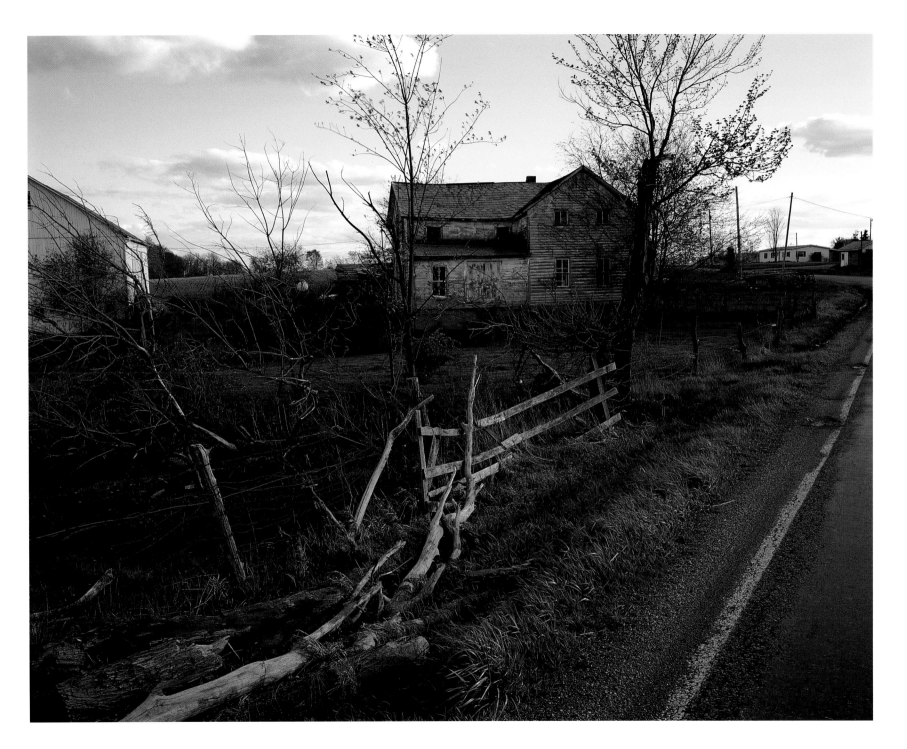

The old fence

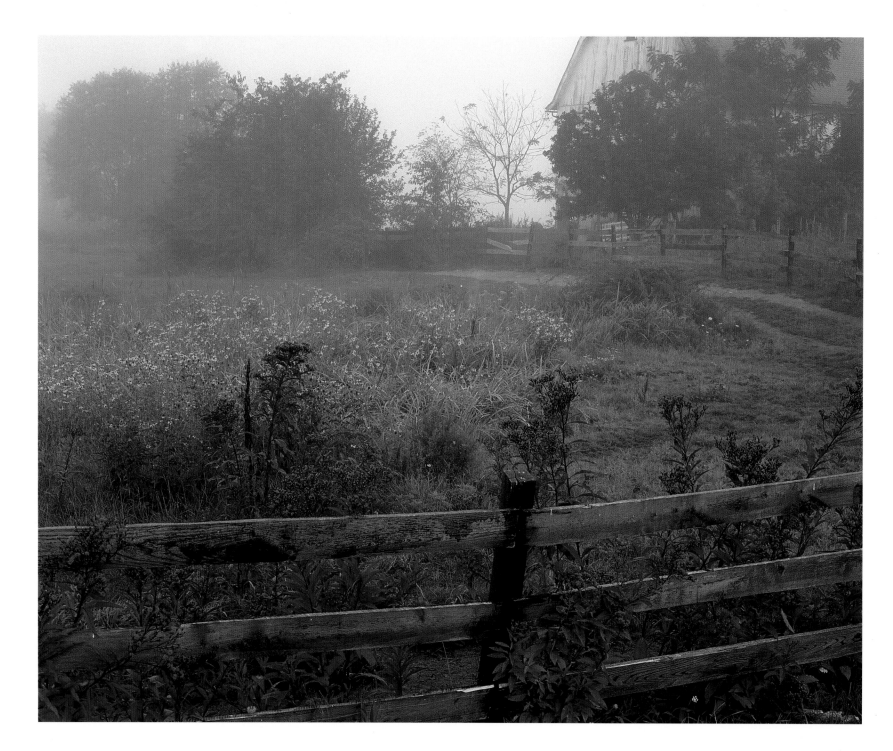

Fence post and flowers

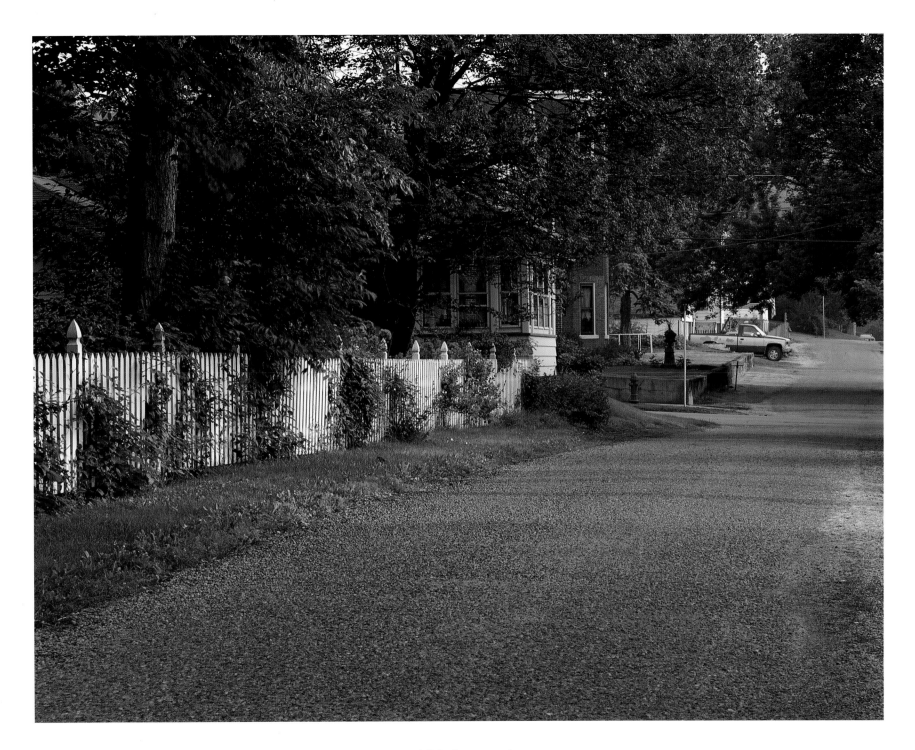

Off the beaten path

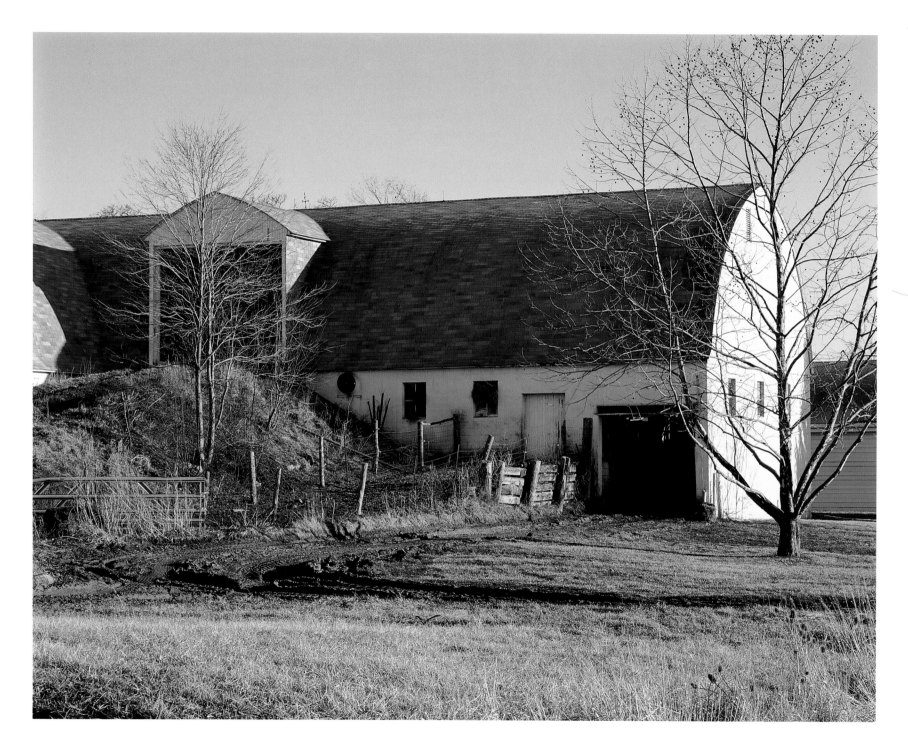

A dairy farm

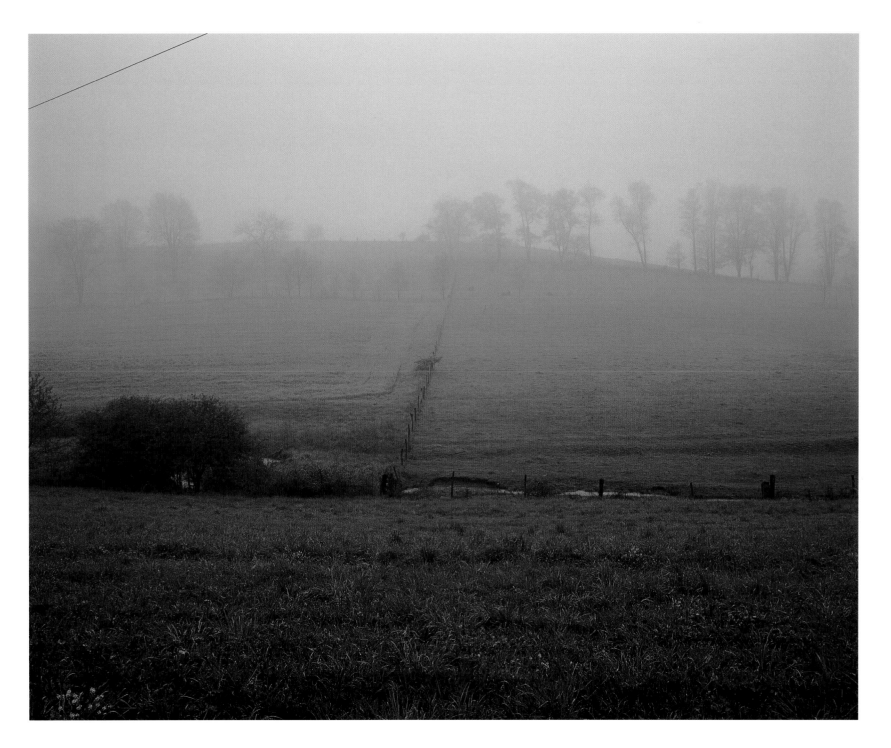

A foggy morning

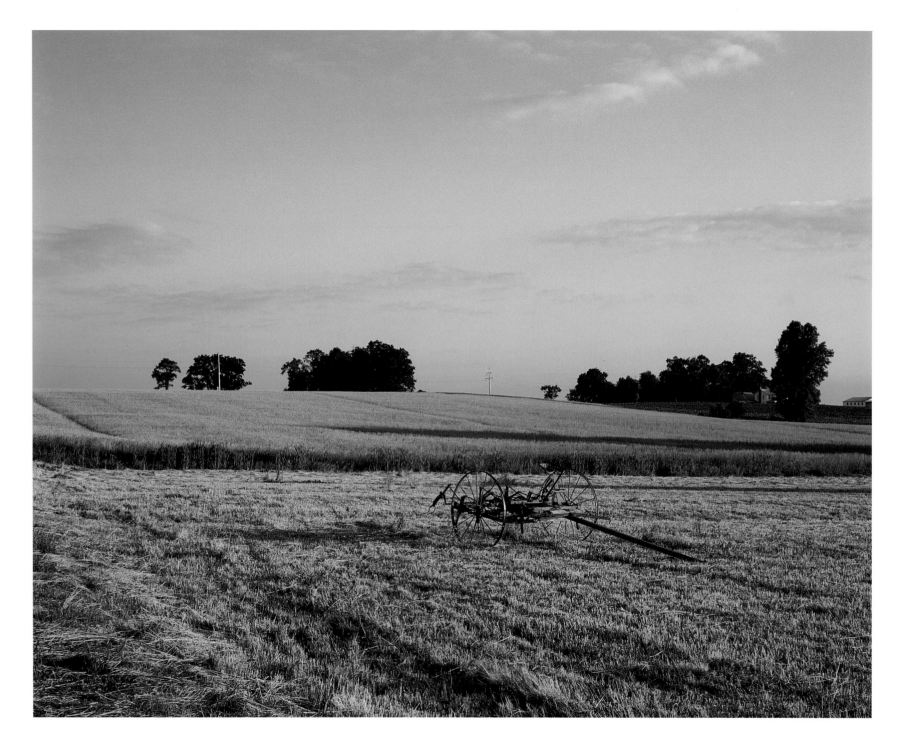

Wheat fields

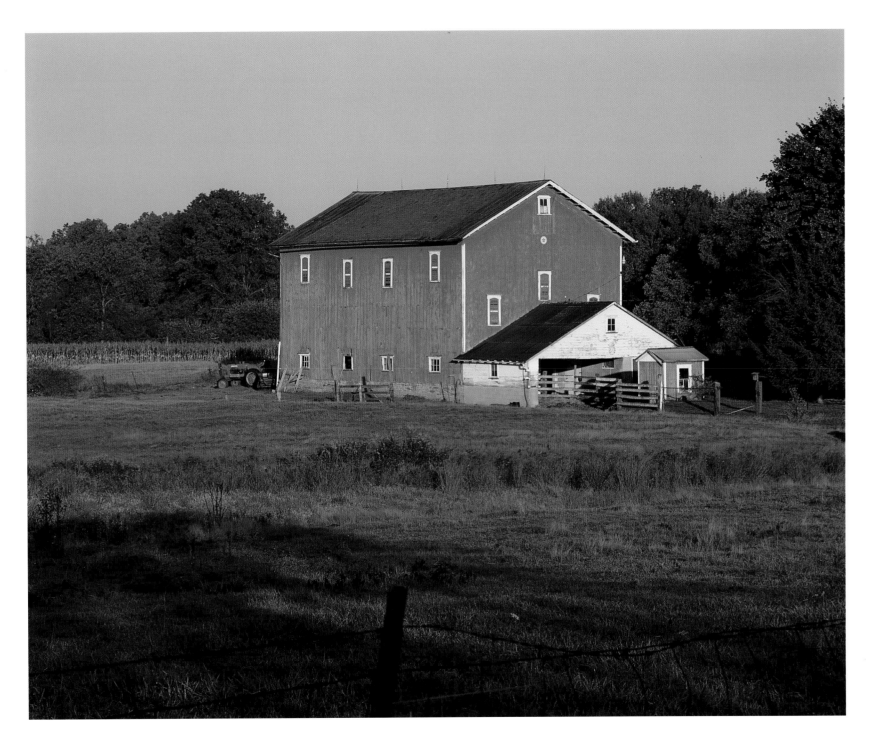

Sunrise in late summer

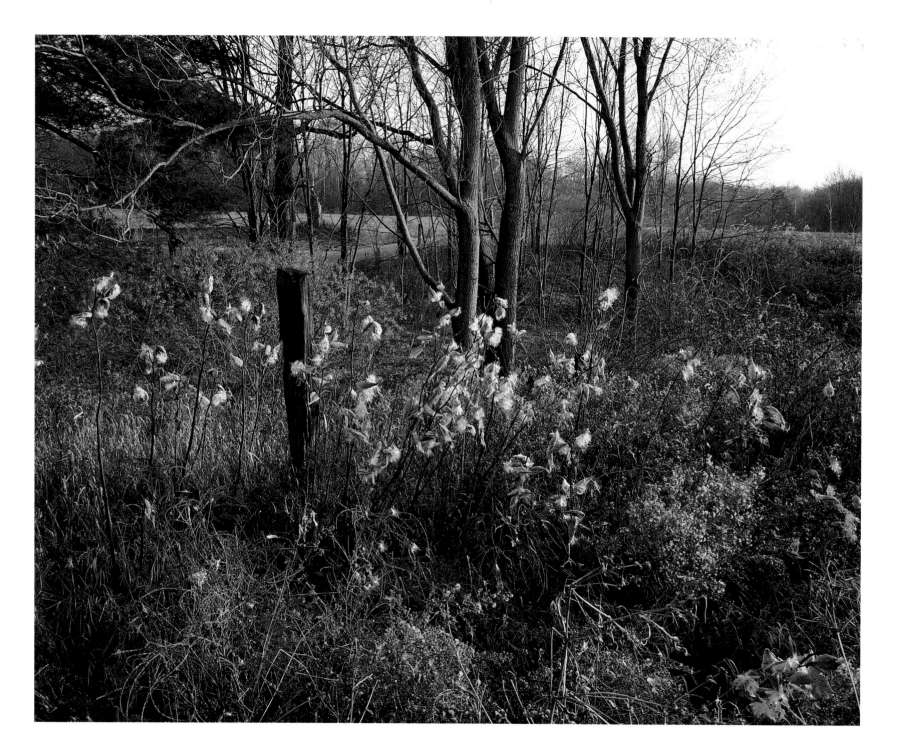

Milkweed

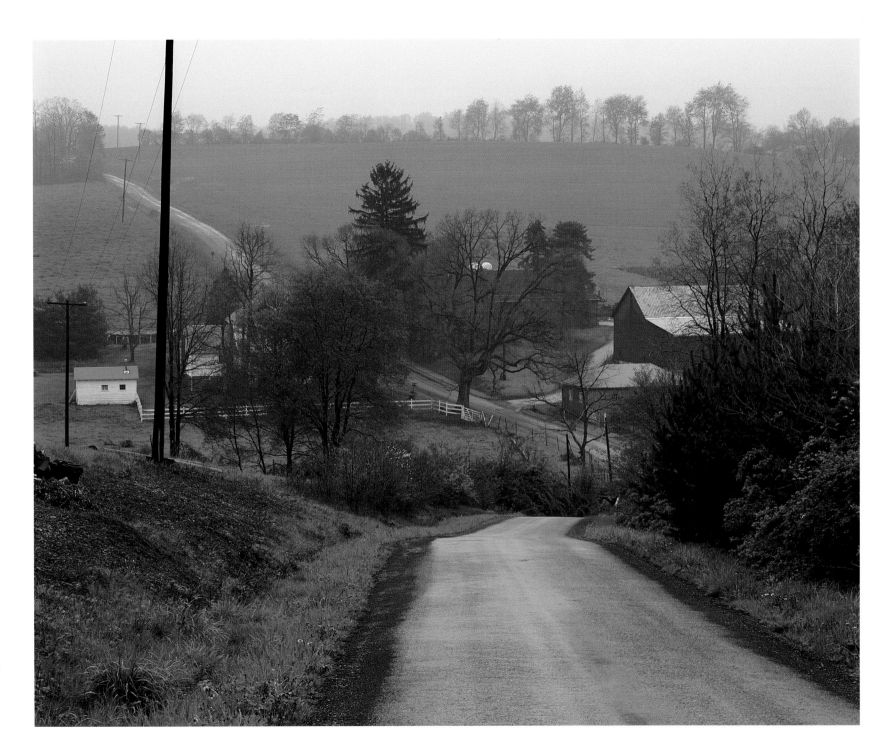

A country road

On Common Ground

was designed and composed

by Christine Brooks

at The Kent State University Press

in 11.5/16.5 Bodoni Book with Berthold Bodoni Light figures

on an Apple G4 system using Adobe PageMaker;

printed in four-color process on 157 gsm Japanese enamel gloss stock,

Smyth sewn and bound over binder's boards in Brillianta cloth,

and wrapped with dust jackets printed in four-color process

by Everbest Printing Co. Ltd. of Hong Kong;

and published by

The Kent State University Press

KENT, OHIO 44242 USA